Essence & Praxis
in the
Art Therapy Studio

Monica Carpendale

Order this book online at www.trafford.com
or email orders@trafford.com

Most Trafford titles are also available at major online book retailers.

Note for Librarians: A cataloguing record for this book is available from Library
and Archives Canada at www.collectionscanada.ca/amicus/index-e.html

Printed in Victoria, BC, Canada.

ISBN: 978-1-4269-1591-8

*Our mission is to efficiently provide the world's finest, most comprehensive book publishing
service, enabling every author to experience success. To find out how to publish your book, your
way, and have it available worldwide, visit us online at www.trafford.com*

Trafford rev. 10/02/2009

Trafford PUBLISHING® www.trafford.com

North America & international
toll-free: 1 888 232 4444 (USA & Canada)
phone: 250 383 6864 ✦ fax: 812 355 4082

CONTENTS

Acknowledgements

There are many people to thank in the development of my understanding of the human condition, creativity, art and therapy. I would especially like to thank and express my deep appreciation for my late partner, Blake Parker, for his love, support and the ongoing dialogue that has been so inspiring. Many thanks go also to my mother, father, my brothers and sisters, my children and grandchildren, for all the love, support, joy, and challenges that have enabled me to grow and develop.

I wish to honour and acknowledge my teachers in art therapy: Dr. Bruce Tobin, Dr. Martin Fisher, Lois Woolf, and Talia Garber. There are also many colleagues and conference presenters from whom I have learnt a great deal. In particular, I would like to appreciate the work of Margaret Jones Callahan, Leigh Files, Deborah Linesch, Katharyn Morgan, Janie Rhyne, Shirley Riley, Lucille Proulx, and Judith Siano.

I apologize if some of what I have learnt has become so much a part of my own work that I have lost track of exactly where it came from. Some of the activities presented in this book have come from workshops and conferences and I don't know if they were ever written up. Also many art activities have been passed on from person to person so I am not sure always if I am attributing the first author. I have done my best to recognize all of you I have learned from.

There are others who have played a significant role in the creation of this book - Jennifer Hakola, my summer student assistant in 2003, did the initial work to compile, and organize the first draft. It has doubled and tripled in growth and gone through several edits and transformations since then and I am very appreciative of Karen Lee-Guse for her editorial assistance and support in revising this final draft. The honesty and clarity, which she has brought to the editorial process has been invaluable. I would also like to thank my clients, students,

and supervisees from whom I have learned a great deal of what I offer here.

I hope that this book can contribute to inspiring creativity and health in individuals, families and communities and will be of value to those entering and in the field of art therapy.

Preface

Essence and Praxis in the Art Therapy Studio has been written as an introductory text on Art Therapy to be used in the context of an Art Therapy training program. This book introduces the theory and practice of Art Therapy as taught at the Kutenai Art Therapy Institute. The approach is quite eclectic and draws from a number of theoretical sources: metaphor theory, social constructivism, hermeneutic phenomenology, eco psychology, earth art, psychoanalysis, object relations theory, gestalt and client-centered art therapy.

The book focuses on theory regarding the creative process, interpretation, the art therapy process and dialogue. It also provides a number of exercises and art activities that can be used in a therapeutic context. It is important for all art therapy students and art therapists to personally explore the art activities prior to any introduction in a clinical or educational setting. This book has been written as an art therapy textbook to be used for training art therapists. Detailed verbal explanations, other variations, therapeutic precautions, feedback in therapist role-plays would be offered in the classroom context.

The first chapter is an introduction to art therapy, looking at the relationship between art and therapy including different views of illness and health. The second chapter discusses metaphor theory and social constructivism. The third chapter focuses on the art therapy process and creativity. The fourth chapter discusses hermeneutics and the phenomenological method in the context of art therapy. The fifth chapter examines interpretative frameworks and the role of symbolic interpretation in the context of art therapy. The sixth chapter addresses the essence and attitude of the art therapist and the importance of therapeutic presence. The seventh chapter explores the creative process and its place in the context of art therapy and healing. The eighth to thirteenth chapters introduce a variety of art therapy activities. The book includes spontaneous art, different media and activities with a

variety of open-ended directives. This list is by no means exhaustive and some of the ideas have come from other Art Therapists – which I have tried to reference as accurately as possible. The fourteenth chapter focuses on art exercises that can be used in supervision, and during training to be an art therapist.

As I complete the writing and revising of the third edition of what previously I called the Kutenai Art Therapy Studio Manual and have now named Essence and Praxis in the Art Therapy Studio, I realize how my approach to Art Therapy has evolved into what I would now call an ecological approach to Art Therapy. Ecology refers to the interrelationships of organisms and the environment. It looks at networks, nested systems, nurturance, cycles, diversity and flow. All of these aspects are a part of being an Art Therapist and are continually present and explored in the Kutenai Art Therapy Institute training program.

We are all related and interdependent on our world: human systems are interconnected and interdependent on natural systems. The whole economic system is dependent on the environment to a much larger extent than previously acknowledged. Social ecology addresses the human/nature relationship in terms of human justice and environmental health being intrinsically dependent and related to each other. Many people all over the world are feeling the destruction of our planet – the violations, exploitation and pillage. Many people are also still living a life as if nothing has changed and yet everything has changed. We live now with the awareness that the world is being extensively, perhaps irretrievably, damaged. We are all accomplices, through society, to this potential disaster or catastrophe.

My much loved partner, Blake Parker, died recently from cancer, and while it is very painful to lose one individual – but to image losing the whole planet because we haven't cared for the world we live in – is unthinkable. We simply must try to restore the balance to make a welcome home place for the generations to come. The environmental crisis affects all of us and as a therapist I see that it affects clients, particularly the youth. It can acutely contribute to their feelings of betrayal and mistrust of their 'elders'. The adults who are supposed to create a good holding environment have compromised their safety.

Originally, in my commitment to be an art therapist, I was intent on freeing individuals from confining knots of emotional pain to transform them into creative individuals with more flow and pleasure in their lives. My concern has been focused on children, families and communities. While I am still focused in this area, I now include nature and the natural environment as "a subject not an object". (McFague, 1997) I am committed to working with respect and compassion towards justice and health for humanity and to an ecologically respectful relationship to the natural world.

This book is offered as a studio manual for Art Therapists, and it emphasizes the ongoing relationship between theory and practice. My writing regarding an ecological model of art therapy and the development of an ecological identity will come in my next book.

Monica Carpendale, 2008

Chapter 1

Art, Art Therapy & Symbolic Healing

Throughout time, mark making and creative activities have been common to people of all cultures; ritual healing practices have traditionally included all of the arts. The use of art in therapy has the potential to help the whole spectrum of human conditions in children as well as adults: normal neurotic, character disturbed, psychotic, physically handicapped. There is opportunity for prevention, therapy and rehabilitation.

Though this book is not intended to be a history of art therapy, a very brief overview of the development of Art Therapy is in order to create the context. Art Therapy is situated within the context of symbolic healing. Haslam (1997) writes:

> Art therapists are the inheritors of a body of knowledge that is much more complex and relevant than the romanticized versions of medicine men. We have a direct line to the original healers because they relied, as we do, on art. Art Therapy is a restoration of the healing power in art, a return to origins. Art Therapy marks the re-emergence of art making as an instrument of adaptation and successful adjustment. (p. 15)

Two significant branches of healing are the scientific or biological approach and the symbolic or cultural approach. Scientific healing includes the use of herbs, medicines and corrective surgery and addresses the use of observable physical facts basing its approach on anatomical, physiological and pharmacological knowledge. It focuses on specific organs or parts of the body and rarely the body as a whole. It covers a wide range of treatment from surgical operations to biochemical

medication. Due to biological commonality throughout the human species scientific medicine can be approached cross culturally. This approach focuses on facts and principles, not beliefs, and, although it may facilitate physical health, it may not restore the individual to a state of harmony with his surroundings and peace of mind. Symbolic healing is more culturally specific as it focuses on beliefs, values, and the individual's sense of self and well being in the community (Sandner, 1991).

The structure and practice of art therapy is similar to symbolic healing practices of different tribal cultures. One can break it down to correspond to similar stages in symbolic ritual healing practices:

> 1. Preparation & Purification: The first stage is the preparation or purification and in art therapy this would be the creation of the art therapy environment, room or sacred space; where there are to be no interruptions and all feelings will be accepted.

> 2. Evocation & Expression: The second stage is the presentation of symptoms or evocation and this would correspond to the expression of feeling and issues in the art making process itself.

> 3. Identification & Significance: The third phase is identification, which occurs when we look at the art and explore verbally its significance. This is when we perceive and identify the feelings and issues at hand.

> 4. Transformation, Insight & Understanding: The fourth stage of transformation is where there is the possibility of insight and understanding.

> 5. Release: The final stage is that of release and in therapy it would be referred to as letting go, closure and separation.

Some of the archetypal healing principles that are common cross culturally can also be seen reflected in the process of art therapy. These

principles are developed in Donald Sandner's book *Navaho Symbols of Healing* (1991):

> 1. Return to the origin of life: Many native symbolic practices involve a theme of the return to the source with a focus on origin myths and the creative interaction in the birth, death and rebirth processes. In art therapy this would be the focus on the individual's emotional life, clients "going back" to their family of origin or the return of emotional feeling after it has been cut off or numbed due to loss or trauma.

> 2. The management of evil: Evil is symbolized so that it can be removed, and in that process, called forth and dealt with. In art therapy there is the opportunity for the safe expression and release of anger, pain, loss and shame.

> 3. Themes of death and rebirth: Without formal rituals for the transitions from one stage of life to another, dreams often symbolically portray the death and rebirth of a new phase. The art making process is a safe place to give emotional and symbolic expression to both one's destructive and creative urges. An individual's myths and transformations can be expressed, discovered and reconstructed in the creative process.

> 4. The restoration of a stable universe: Regression is reversed, transference resolved, and the patient restored back in the midst of his or her life. The concrete nature of creative art making facilitates the individual's ability to come to terms more objectively with their perceptions of the world.

In western civilization there have been a number of significant parallel streams that have developed into Art Therapy, as we know it today. Artists were influenced by the development of psychoanalysis and Freud's book *The Interpretation of Dreams* (1895). In the 19th century, attention started to focus on the art of the mentally ill that

was being created in a variety of the asylums. Hans Prinzhorn collected over 5,000 pieces of artwork from psychiatric institutions in Europe and wrote a book entitled *The Artistry of the Mentally Ill*, published in 1921. This book was also influential to artists at that time.

In medicine and rehabilitation, art therapy was pioneered by Adrian Hill in England, who introduced it to the treatment of soldiers traumatized by the experience of the Second World War. In 1945, he wrote *Art versus Illness*, which documents his own use of art in a sanatorium recovering from tuberculosis and his subsequent development of an art program in the sanatorium. Edward Adamson worked with Adrian Hill in the sanatorium before he was invited to speak about art to the residents of a mental hospital. In 1946, Adamson opened the art studio at the Netherne Hospital for the mentally ill patients.

During World War I, Jung started a personal exploration of art through creating mandalas. In 1928, he started encouraging visual expression using art with his clients to amplify dreams and symbolic communications.

In 1914, Margaret Naumberg founded the Walden School, which was based on psychoanalytic principles and emphasized the arts. She was one of the first people in the United States to undergo analysis with both Jungian and Freudian analysts, concurrently, of course. The release of unconscious imagery was central to her approach to art education and later to art therapy. Naumberg (1996) called her approach "dynamically oriented art therapy". It was theoretically based on Freudian concepts while also incorporating Jungian ideas of universal symbolism. Judith Rubin (1987) wrote that

> as an artist and scholar, knowledgeable about many schools of thought regarding symbolism, she [Margaret Naumberg] insisted that the only valid meaning of anyone's art was the one which came from the person himself. She was skeptical about simplistic or rigid approaches to decoding symbolic meaning, a position consistent with Freud's teachings regarding dream analysis. (p.11)

Naumberg's sister, Florence Cane, taught art to gifted children and developed her own methods for stimulating creativity through

spontaneous gestures. She wrote a very useful book for art therapists entitled *The Artist in Each of Us* (1951). In the 1920's Melanie Klein, child psychoanalyst, started using art in her sessions with children. Art educators and theorists, Herbert Read and Victor Lowenfeld (1947) in England, also influenced the development of art therapy. Since the 1950's there have been a number of significant pioneers in England and North America: Edith Kramer, Marion Milner, Marie Revais, Martin Fischer, Irene Dewdney, Helen Landgarten, and Elinor Ulman to mention a few.

There are many different approaches to art therapy. These approaches developed within different client groups but underlying the different developments is the belief in the natural healing capabilities of art. In general, Art Therapy involves the use of art and other visual media in a therapeutic or treatment setting. The field of Art Therapy can be thought of as on a continuum or as a series of overlapping circles moving from a position of art as therapy through art therapy to art psychotherapy.

Art as Therapy focuses on the intrinsic, natural healing power of creating artwork and catharsis of creative self-expression while Art psychotherapy involves the use of art to bring unconscious material to consciousness particularly through verbal associations and dialogue. The art as therapy approach tends to view the creative process as healing in itself and focuses to a greater extent on sublimation, relief of stress, self-mastery and self-esteem connected with the creation of an artwork. Without wishing to over simplify Art Psychotherapy tends to focus on the person and the artwork is used to give expression to the individual's feelings and experiences.

Art Therapy utilizes aspects of both: the psychotherapeutic dialogue is integrated with the intrinsic therapeutics of the creative process of art making. Art therapy in general moves along this continuum and focuses on the creative process, moving between looking at the artwork and exploring in depth the inner life of the individual. Art therapy can be both a primary mode of therapy and it can compliment other forms of therapy.

From a psychoanalytic perspective the use of art in therapy provides an opportunity for accessing the unconscious in a more immediate manner and for concretely visualizing the conflict.

Through the artwork and the verbal associations one finds evidence of the unconscious, making visible the roots of the present emotional state. Techniques of spontaneous expression and free association are emphasized. Unconscious material, dreams, fantasies, wishes, lies, and memories tend to elude internal censorship in the art making process. Surprises may emerge and new connections can be seen as one moves from a linear process of verbal communication to the opportunity for simultaneous expression. While we may be able to tell the same story a number of times, which can have a tendency to reinforce our own perspective, it is very difficult to repeatedly paint exactly the same image. The image changes in the creative process and the thoughts and feelings change also. The tangible nature of the artwork can facilitate the verbal associations thus providing a bridge to consciousness.

Barthes (1952) writes about how images and art do not analyze or dilute meaning but present it simultaneously and thus are more immediate and imperative than writing. The expression of one's emotions in the art is a concrete tangible underpinning for verbal free associations. It enables one to bypass the distortions created by the meta-language of the individual. It is through the analysis of one's personal structure of meaning that one can come to a different understanding and make different choices.

The fundamental concepts of psychoanalysis & object relations underpinning art therapy are:

1. The emotional life of an individual is seen to be continuous from childhood into adulthood.

2. There is continuity between our conscious and unconscious mental life. Every part of our mental life has meaning and a large part of our mental life is unconscious. The unconscious part of our mental life does not readily reveal itself. It is evident in dreams, humour, and everyday slips of the tongue and in art. There is an underlying structure to how the unconscious functions. The role of anxiety and use of defense mechanisms is significant.

3. The technique of free association is used to get to unconscious material.

4. Art and dreams give expression to repressed thoughts and feelings related to conflicts, traumatic experiences, fantasies,

dreams, self images and symbols, patterns of relationships, defensive operations, impulses and reactions to the past, present and future. The inclusion of artwork helps in understanding transference and counter transference dynamics.

Illness, Disease and Models of Healing

To talk about therapy and healing we have to first talk about concepts of health and illness. I would posit that to be healthy an individual requires flexibility, resilience, freedom of choices, and meaning. A sense of well being also has to do with feeling understood and accepted as one is and not defined as how one should or shouldn't be. Generally speaking disease refers to the physical components of a disruption to health and illness refers to the emotional and social components.

In all cultures there are two main archetypal models of disease. One refers to the loss of soul or an injury to the soul and the second refers to a foreign intrusion or invasion of something other than self, a violation of the boundaries of the body. (Sandner, 1991) The imbalance in health in this way can be viewed as either a subtraction or an addition. Applied to a medical situation the issue of loss could refer to loss of blood, consciousness, or a body part and the issue of intrusion could refer to a cancer, rape or a beating. Art Therapy can be used in healing within either model.

Individuals seeking healing are generally experiencing some kind of emotional, physical or mental pain. We experience pain physically as a communication from our body to pay attention to a particular area. We have to learn to encompass pain in our concept of health and to not view it as necessarily a bad thing. There is what might be called pain in the experience of childbirth and yet the experience is so intermingled with pleasure that the pain is more a complete intensity of feeling. Our resistance will intensify the pain and letting go will allow the baby to be born. Our difficulty may be with accepting the intensity of the human experience. The human experience includes pain and suffering as well as joy and pleasure.

The purpose of therapy is to create as large an area in the person that is conflict free. Therapy is a process of looking beneath the defenses to unearth the underlying conflicts and work through them, to thus resolve and put one's emotional life on a firmer foundation. Neurosis refers

to the process by which an adult may repeat problematic behaviour that has been learned as a child. The intention of therapy is to resolve the neurotic components in order to provide more flow of energy and pleasure.

There is a big difference symbolically between viewing insight as a discovery and revelation or as part of the creative process and therefore a creation. The spectrum of possibilities is there – there is no doubt that the creative process takes the artist/client through a process of deconstruction and re-creation. In exploration through art or in dialogue this underlying question as to whether something that is hidden is being revealed or is a hidden potentiality being created is significant for the individual to begin to have choices, not based on the original pattern.

The two basic models of therapy are the medical model and the growth model. There are a multitude of variations in between. A medical model intends to heal and implies sickness (disease) in the individual. The growth model views illness as blocked growth and development in the emotional and social spheres. Therapy is viewed as a developmental process with the individual having unlimited potential for growth. Both models have advantages and disadvantages. Although I tend to favour a growth model, the metaphor for unlimited growth as a model has some inherent problems from an ecological perspective. All cycles of nature have beginnings, middles and ends: periods of intense growth and periods of rest or dormancy. Essentially, it is important to explore the metaphors for healing that the individual uses and to find ways to enhance or amplify their vision of health.

In any person there can be both internal and external threats. External threats can include social and interpersonal threats to the body and the psyche as well as more global threats of war and environmental change and disaster. At one time external threats were perhaps less global or visible in the media, although they have always been there. We may have defenses against some of these and not against others. Denial is often used by the masses to avoid living in total panic. This corresponds to the individual situation where death and separation can be experienced as constant threats. We will all experience such losses through our lifetime. From an existential perspective, life is viewed as

impermanent to the extent that we don't know where we are going to die or rather when we are going to die. This causes anxiety.

Internal threats consist of various desires and impulses. Social upbringing, cultural and religious beliefs may have led us to regard these as unacceptable. Parental and societal edicts - the do's and don'ts - have a great impact on us. Even if our impulses and desires are unacceptable they don't go away. Hunger doesn't go away - you can wait but you are still hungry.

From a psychoanalytic perspective these unacceptable impulses are viewed as emerging from the id and the anxiety generated comes from the fear of super ego reprisals. Anxiety functions like a fire signal and the ego brings up defenses for protection. Under normal conditions these defenses are adaptive and allow the individual to carry on a normal life. However, some are maladaptive and may interfere considerably with normal activities. The underlying psychoanalytic belief is that symptoms reflect wishes and drives which conflict with upbringing and societal norms.

It is important to be aware that all neurotic symptoms have a purpose and to consider what the symptom or behaviour is an alternative to. Phobias, anxieties and compulsions result from the individual's attempts to cope with the anxiety, which arises from unresolved intra-psychic conflicts. In psychoanalytic terms, acute symptoms reflect the conflict between what one wishes to do stemming from the id and drive energies, and the conscious ego or super ego reflecting the external prohibitions of our contextual reality. Internal prohibitions are represented by the consciousness of the ego and super ego and the individual may be trapped with anger, aggression or sexual desire. Invariably as one talks about the present day emotions and the pain in an individual's life one finds that they have roots that go back to childhood.

The Focus of Therapy

Dr. Martin Fischer, an art therapy pioneer in Canada, spoke in class of how individuals seek therapy in order to both understand themselves and to be understood by another. In fact, he said, "It is the essence of all human need." (1985) This places the individual with needs for health in a social context and in relationship to others.

Some of the reasons people seek therapy are because of:

1. A betrayal of trust in relationships;
2. An inability to cope with life situations and/or social stress;
3. Intense feelings of loss, unhappiness and pain;
4. An injured sense of self and self-esteem;
5. Experiences of intense unresolved anxiety and grief;
6. Current issues and difficulties stemming from childhood trauma, losses, unmet needs, fears, and histories of family dysfunction, or problems with attachment.

From a growth model the focus of therapy is to learn about oneself. We may try to escape into the external world to avoid ourselves: to avoid knowing ourselves. Often, it is out of ignorance that internal human conflict emerges. Our emotional state fluctuates and we may not want to be committed to a certain way of feeling. We can discover and give recognition to the positive aspects and the obstructions within. Obstructions can be looked at as underdeveloped aspects that need to change; they need an opportunity to grow, flourish and evolve. Creativity can encourage the healthy development of flexibility in our emotional life.

Some people are looking for insight and are ready for depth work and others are in such a vulnerable state that one needs to support the ego via the art, gently releasing emotions and constructing a worldview. Often it is thought that therapy is a process of breaking down defenses; however the defenses have developed for good reasons and sometimes you will find that a client needs more defenses not less. The important thing about defenses is to understand them and to see how they function in one's life and to be able to ascertain whether they are useful or problematic. Perhaps a defense that was once essential is no longer appropriate or perhaps we are using the wrong defenses in certain situations. The key is flexibility: learning when and how to be open, to have control and choice and be able to recognize safe and unsafe situations.

Individuals also engage in the therapeutic process to develop more self-awareness and to discover or create meaning in their lives. Therapy may have elements of mirroring or confrontation: bringing the client face to face with those hidden aspects of self that are revealed in the art but have remained hidden from the client. Generally speaking, interpretation will be an aspect of the therapeutic process, which means

the therapist has an opportunity to explore the expressed feelings and behaviour in relationship to the client's motives whether they are overt or covert, manifest or latent. To avoid the imposition of meaning it is best if the interpretations come from the individual and continue in dialogue with the therapist. Timing is of the essence and must always be taken into account. Sometimes a client is not ready to see what is there.

The Universal & Relative Aspects of Art & Therapy

It is important to keep in mind that both art and therapy have elements that are universal, and elements that are relative.

Universal Aspects of Art	Relative Aspects of Art
Form	Cultural components
Colour	Personal perspectives
Shape	Personal symbolism
Creative expression	Individual creative expression
Symbolic meaning	Skills & techniques
Universal Aspects of Therapy	**Relative Aspects of Therapy**
Human development	Social construction
Formation of personality	Cultural components and
Bodily functions and needs	world view
Developmental stages and	Differences in families
processes	Differences in environment
	and culture

It is often said that there is a universal language of pictures. Through common images emotions can be expressed. The images produced form the communication between the client and the therapist; they constitute symbolic speech. The symbolic speech corresponds to Roland Barthes' (1952) definition of 'myth' as a type of speech, a mode of signification. The historical foundation of one's personal mythic structure is in the conscious and unconscious memories of the relationships and experiences with the family of origin.

The Process of Art Therapy

Initially feelings are expressed in the artwork. This consists of spontaneous activity with simple art materials (clay, paint, crayons), in a non-judgmental, non-threatening atmosphere that allows the person to express him/herself in a safe way. Art therapy cuts through gaps in the communication of feelings, by allowing individuals to express inner thoughts and feelings symbolically. Then a process of looking, exploring and discovering can be engaged in. Active and voluntary free associations are encouraged and discussed as they pertain to any particular difficulties the individual is experiencing and wishes to understand further. This serves as the cornerstone for understanding the disorder/ discomfort, as well as the dynamics involved. Each session will have a beginning, middle, and an ending. Likewise, therapy over a period of time will have a beginning (building of trust and rapport in the relationship), a middle (a period of intense personal exploration), and a closing (a period of integration and separation).

The Art Therapy Environment

The art therapy room is the environment, the context in which the therapeutic work occurs. Some art therapists call it 'the creative arena' or 'potential space' (Dalley & Case, 1992). When thinking about healing and growth in a holistic manner one must always remain aware of acting within an environment. Attention must be paid to the kind of environment created with regard to light, air quality, warmth, privacy, accessibility to materials, and permission to mess or create.

To set the scene I would like to describe an art therapy environment, which is not much different from any art environment. The tables are set with simple art materials: paper, paints, brushes, pencils, pens, pastels, clay, collage and construction materials. It is important to not have dangerous or toxic art materials or tools. Tea or juice and a light snack might be offered. Individuals are encouraged to express themselves spontaneously using the materials.

Sometimes a directive might be given or a new material or technique introduced. It is important to create an atmosphere conducive to creative possibilities, which might include making a mess. The quality of the relationship with the art therapist is central: creating

the context of freedom within which the individual makes his or her communications.

Differences and similarities between art and art therapy.

Sensory experience:
In creating art – whether in the context of therapy or not - all our sensory perceptions are active, we see things, we get ideas, we use shape and colour and line.

Interpretation:
In art therapy, first we express our perceptions and then we reflect and interpret our emotional perceptions. You might say that this is a normal process for an artist and I would agree but also point out that there is a difference when facilitated by a therapist. What is this difference? We all interpret signs and symbols all the time and it is important for the client's progress that they interpret. The client has the inherent ability to solve her or his own problems. However, without the dialogue with the therapist and without an interpretive framework there wouldn't be direction or objectivity to the questions.

Context:
Art created in the therapeutic environment tends to focus more on the individual artist/creator's feelings, historical relationships and present situation in the world. While style, culture and the historical context may be pertinent to the individual's issues it is not important to create "fine art" or to relate to the concerns of a fine art context. The art is created in the context of the therapeutic environment and is intended to be both an expression of self and a dialogue with self and thus a focus of the therapeutic exploration and dialogue.

Goals:
At the initiation of both art making and art therapy the end product remains unknown. Both involve a process of discovery. Some approaches in art therapy emphasize the end product, others emphasize the creative process of art making, and others the individual artist. These kinds of concerns are also contemporary art concerns. In fine art, the

goal may vary with the artist in their desire to be understood or interact with an audience. However, in art therapy, the goal is to understand oneself and to feel understood by another. It is Hegel, I believe, who reframed art as presentation not art as representation.

The focus in art therapy often simply becomes the conditioning factor in the process of the work of the artist. The unique cultural and psychological conditioning of the artist forms and controls the vision of the artist while remaining inexplicit in the work.

Product:

Perhaps we could say that art therapy offers a gift and communication to oneself and art offers a gift and communication to oneself and to society. While art therapy offers personal insight, art offers insight to others (to see life through the artist's eye).

Process:

Therapeutic work is involved in a communicative process whereby the self talks to the self (often through the mediation of the therapist). The goal is self-knowledge and the opening up of various life options, behaviours or choices. The therapeutic alliance provides a safe environment to explore difficult emotions. Art also is a communicative process whereby the self talks to some other, usually unknown individual or group, about one's concept of reality and one's place in the world. It is only incidentally that this audience may communicate to the artist. They communicate to the artist by valuing and purchasing their artwork.

Therapy, the Concrete Art Object & the Creative Process

In the art therapy process, the creation and observation of a concrete art object functions to objectify and externalize some aspect of the interior life of the artist/client. I am choosing to use the term artist/client to refer to the client in therapy because I want to emphasize that everyone that engages in the creative process is an artist and that the identity of the client can be dignified by the seriousness of the personal expression of an artist. In fact in many of the successful outcomes of art therapy, clients emerge as artists in their own right. Art making and the creative process become a means of making meaning, of self-

expression, of pleasure and a tool in self-understanding. The tangible artwork created in the context of therapy brings specific qualities into the therapeutic relationship.

Reality:

Because the image is tangible and concrete, it is difficult to deny. The physical materials and the physical movement required to make art brings the tangible actual world into direct relationship to the creator's consciousness.

Simultaneity:

The artwork can present simultaneously the different emotions or aspects of a situation; it can present ambivalence and give reality to the circular nature of life avoiding some of the pitfalls of linear or rigid thinking. For example, for First Nations people this particular aspect is relevant as it corresponds to a circular view of life as represented by the medicine wheel.

Objectivity:

The image, the feeling, or the situation, is seen as separate from the self. This assists in the process of becoming objective. The art can be viewed from a distance and placed in perspective. The sensual and evocative nature of the artwork can facilitate the verbal associations thus providing a bridge to consciousness.

Symbolic Self Reflection:

The use of art in therapy allows cognitive and symbolic meaning to become transparent and available for the client to perceive and develop insight. The artwork may become symbolic of one's present state of being. Through the process of defining it visually and then translating it verbally one may realize that one has changed. Also, once the individual has concretely articulated a self-concept, then one may begin to change it. The artwork can serve as a record and give a sense of the permanence of understanding - of actually having been heard, of the pain and trauma actually being witnessed by another. It is difficult to deny the reality of the art, difficult to erase the emotion that is expressed.

Durability:

After the art work is created, the very fact of being able to look at the art over time facilitates the process of self reflection and integration; one can refer back to an individual piece and/or one can see the art in sequence thus clarifying the individual's personal journey.

Visibility of defense mechanisms:

In verbal therapy, the process is at once more linear, more ephemeral and more susceptible to defensive maneuvers in order to preserve old habits and behaviours. Although we may want to change in therapy, the actual process of "shedding one's skin" is most likely to be uncomfortable if not actually painful. The reason for this is that we have survived to this point with our present construction of the universe, our present system of defense mechanisms, our present construction of identity.

Safety for exploring change:

To grow or change always entails a risk, a move into unknown territory and in the art we can safely explore various possibilities.

Blue Print:

Art making provides an opportunity not only for exploring past issues and personal dynamics but also for recreating the self. The artwork can also help to establish the "blue print for the future", as wishes and strengths and emotional support may also come to light.

Boundaries:

There is an opportunity to establish personal boundaries and to develop mastery and self-control with the art, both with materials and with the art making process.

Self-mastery:

There can be a great deal of satisfaction when creating a powerful or playful work of art.

Pleasure:

The opportunity for kinesthetic and sensual pleasure in the creative process encourages the physical and emotional reorganization of the sensory spectrum within the construction of the self. Art making can bring pleasure and playfulness back into life.

Sensory Stimulation:

The art materials provide sensory stimulation and kinesthetic pleasure, which activates memories and connects feelings to sensations in the body, thus providing an opportunity for integration between the psyche and the soma. For a physically handicapped individual art therapy provides an opportunity to physically engage in an activity that promotes not only emotional reorganization but also the reorganization of the sensory spectrum that may have been disrupted by injury or handicap.

Control in the therapeutic process:

Art provides a client a way to control, to order and to map out the confusing sense of the body and the environment and of time and space.

Self-expression:

Creating art enables a client to give expression to difficult emotions and allows latent unconscious content to become manifest and available for new understanding and insight.

Emotional discharge:

The underlying premise in the art as therapy approach is that the creative process itself is healing by providing an avenue for cathartic release of emotion via sublimation of desire. This experience is integrated with the cognitive development of personal skills and understanding. For an emotionally abused client it provides an opportunity for emotional discharge through the aesthetic and kinesthetic pleasure involved in the process of art making.

Control and Independence:

Creating art in the context of therapy enables the individual to take an active part in the therapeutic process. The client is helped to develop autonomy and independence via his or her growing interpretative ability in regard to the artwork produced, thus increasing self-awareness and decreasing dependence on the therapist. The creative process provides ample concrete opportunities for problem solving and empowers the client in their therapeutic process.

Responsibility:

The artist/client becomes symbolically and physically responsible for his or her growth and development. It is through the artwork and art making process that issues are brought to the fore and examined. The creative process also provides an opportunity for reworking or recreating feelings and a sense of self into the future.

Empowerment

Art therapy can be an empowering therapeutic process. The artist/client learns tools for self-discovery and interpretation and has the opportunity to express and release intense feelings of grief, pain and/or trauma.

The Value of Art Therapy

The purpose of art therapy is to bring to light some of our internal condition. In the process of art therapy we are looking for an integration of our lives and we journey inside in order to understand that which is outside ourselves. Throughout the art therapy process the dependence on the therapist decreases as the individual develops the ability to interpret his or her own art. The feelings that are expressed in the art making process become transformed through the creative process and through the formation of symbols. The artist/client has the opportunity to creatively develop a transitional object and thus develop the ability to symbolize or make substitution for the real thing. In the art making process one can develop understanding, and regain control and choice in situations that appear in life to be ones in which you have no understanding, control or power.

Chapter 2:

Social Construction & Metaphor in Art Therapy

Social constructivist theory and narrative therapy focus on how each of us has invented the world in which we live. Of particular interest is the way we use words (language) and how we interpret the events of our lives, both in the present and in the past and then how we connect these events sequentially in a narrative, thus creating meaning, which informs how we live our lives. (Riley, 1999)

Art therapy provides an opportunity for exploring an individual's emotional reactions, their difficulties and strengths. The creative process of art making enables the individual to discover, to reframe, to create new models and metaphors. The focus is on assisting the individual to develop his or her ability to interpret his or her own art.

The basic concept of social construction posits that the social world and indeed our whole idea of the nature of the world has been, and is, socially constructed via metaphors or symbols. These symbolic constructions organize and guide behaviour. As such, all aspects of the social world, including the self, all social institutions, including those of religion and therapy only appear to be fixed or "natural." In fact, they are malleable and very changeable as can easily be seen in any cross-cultural study of social institutions. The social construction of the development of the self takes place over a great number of years in the context of social forms and other people. In order to become a person in society we must learn the language, learn how to behave in different situations, learn how to be a "good" person (or not), learn how to work and to play, take on our identity (with regard to gender, ethnicity, sexual preference etc.) and take on a role or, actually, many roles.

A social constructivist position posits that we do not discover "reality", but that we "invent" it. (Watzlawick, 1984, Riley, 1999). We may discover something that we were not conscious of, had forgotten or not considered in that light. We may create something new in either the art making process or in the dialogue looking at the art. When this occurs in the therapeutic session it may be considered as a co-creation of meaning. In essence, the world and the self are not there to be discovered but are actually to be created. We create new worlds in each of the relationships we are involved with. We do this in dialogue, in language - and in art therapy we use the art to create.

Metaphor is a way that we symbolically come to understand what is unknown through what is known or more familiar. Metaphor involves the cognitive and emotional grasping of a more or less unknown concept or idea in terms of another better-known concept or idea. During the art making process one becomes aware of the symbolic and metaphoric process by expressing our understanding of our predicament in the context of our understanding of the human condition, for instance, the difficult to define concept of the human soul is very often understood in terms of metaphors of birds, flying or light. Art therapy focuses on the making of models in the form of metaphor, which can reflect, and function in the dynamics of change. During the art making process awareness emerges regarding the metaphors we use for ourselves to express our life situation and the human condition. In the therapeutic process, one can creatively explore alternative metaphoric models which can then function to reconnect the psyche and the body, personality and community, the mental and emotional life and so on.

Metaphors interconnect the basic elements of human nature. Using images and words creatively can help to reconnect the psyche and the body. For example a woman in art therapy painted a crow flying over water. One of the crow's wings was smaller and more awkward than the other. When the painting was put up and looked at, the woman was surprised by the difference in the wings and upon self reflection revealed that she had had surgery for a slow growing benign cyst on her brain which had to be removed some years previously. A result of the surgery was that she had to change from being right handed to being left handed, thus the awkward left wing of the crow in the painting.

Metaphors can explore the unconscious, by-pass defenses and shatter old paradigms. They can operate at a depth where opposite truths may be paradoxically valid, and change perceptions of events and interpretations of experiences. For example an image can hold the ambivalent feelings of both love and anger towards an individual. Forming images and exploring metaphors can give direction and insight into rambling thoughts and feelings. One woman drawing images associated with her suicidal feelings (which showed her overdosing and being taken to hospital and then sitting up in a hospital bed) discovered that what she really wanted was to be taken care of, not to die.

A combined language and art approach to therapy involves staying with the metaphor and exploring it fully in relation to the art, the artist/client and the therapist. New insights may be discovered or created through the process of making art, looking at the art and/or talking about the art. There is always the possibility of perceiving a new perspective or introducing a new metaphor. The process of describing a piece of art will reveal the individual's metaphorical language and his or her individual combination of symbolic and social constructions. I think that part of the mystification of art therapy may have to do with the avoidance of looking at language and how we construct our reality via language.

Words and metaphors can contain a magical power to transform. When a man and a woman are pronounced man and wife, they are now considered married and both their concepts of self will change and the community's perception of them changes. Yet physically, at that moment they are still each individuals and it is only the speaking of specific words that has made a monumental change in their life.

It is important to explore the artist/client's beliefs and metaphors around the reason for therapy and his or her view of healing. Metaphors for therapy or healing could be focused on. For example, we could look at the metaphors of gardening and apply them to therapy. A garden needs good soil, nourished by manure or compost (our past experiences both positive and negative), seeds (insight & potential for growth), water (tears), sunshine (acceptance, pleasure), pruning (exploring issues and defenses), supports and weeding (therapeutic relationship), and a fence (boundaries for therapy).

Through the process of art therapy one can observe the growth and development of an individual in the art. Motifs, styles and subjects change reflecting inner changes. The unconscious message provides the artist/client with a personal position - the place where he or she is situated emotionally in the moment. As the artist/client creates more art, changes can be seen in his or her perspective or position. They can shift forward and reverse back. Metaphorically speaking, it may be a journey with mountains, plateaus and crevices where sometimes one is moving forward and sometimes backtracking. Emotional pain is often expressed through metaphor - sometimes as a wound, disease, baggage or garbage. In therapy one might refer to feeling like a flower unfolding, or a baby being born.

The growth metaphor is interesting and commonly used. What does a plant need to grow? Good soil, nutrients, water, sunlight and an adaptive and facilitating environment. What if it has too much water like, for example, a tree in water? Could there have been a flood? If the tree looks strong but has water around its roots it may indicate that it is under present duress but has been recently strong and growing. Some plants require pruning and some have dormant periods in the winter. What does an animal need to grow? Are nurturance, social relationships and a safe living environment enough? Any and all of these aspects could be significant in enhancing an individual's acceptance and understanding of their life. Amplifying metaphors expressed in the art can facilitate the development of new perspectives.

It is important to remember that just as with interpretation the making of metaphors both reveals certain realities and understandings and obscures others. Thus, the "unconscious" may be understood as a symbol-making container whereby events, feelings and ideas, which are not admissible to consciousness, manifest in a disguised form. In one sense, then, art therapy involves the uncovering of the unconscious roots of certain metaphors (i.e. those found in dreams or art) and through the interpretive process transforming them into other metaphors and/ or linking them up into a congruent pattern of understanding which takes account of both past realities and present needs.

Uncovering is one metaphor where we can think about how things are covered up and how they get uncovered. For example, it could be a blanket, dirt, or snow. The idea of roots pertains to a plant or tree as a

metaphor. The use of the word 'trigger' refers to a gun, weapon or tool metaphor. Even having a new sheet of paper can be a metaphor to have a new experience of self.

A cautionary note must be made: symbols and metaphors are multi-dimensional and cannot be reduced to single meanings. When it is a symbol it speaks infinitely and when it is constructed into words, it becomes limited. Symbols and metaphors can grasp a whole number of aspects in one simple formulation. It is important to see metaphors on a continuum with positive and negative aspects. The interpretive process thus should occur in a dialogue between the client and the therapist. There will be no single correct interpretation.

Through the use of metaphors and symbol formation we create our world: we do this in dialogue, in symbolic expression and reflection. Art therapy is involved in teaching how to create, how to make that which was rigid more fluid, that which was numb or dead, more lively. One woman referred to this process as coming out of the deep freeze. She started having physical and emotional sensations and reactions that she didn't recognize or know how to identify but her use of metaphor in the art provided an opportunity to translate her inner experience to words, thus introducing more cognitive awareness.

If one views the growth of consciousness in terms of a growth of understanding which is in turn linked to the ability to manipulate symbolic language, one can easily see events in terms of different metaphoric models.

I hold the position that language and metaphor are the main means by which we are constructed. I consider the art products made in art therapy to be essentially metaphoric and to be considered as "language". Visual and plastic art functions as "text". In the context of Art Therapy, the interpretation of the artist's works (texts) takes place in the presence of the art therapist who functions as a witness and in dialogue between therapist, artist/client and art (text). Art Therapy can function to construct or reconstruct identity through the creative act.

Perception and Metaphor

All perception is meaningful perception. All meaning is metaphorical. All metaphor is grounded in real experience. Therefore all metaphor has a conventional arbitrary aspect and an unconventional

perceptual aspect. Those two elements of metaphor form a figure ground gestalt. The two different kinds of metaphor are:

a) conventional metaphor which is arbitrary and dominates perception;

b) creative or unconventional metaphor which reverses gestalt and perception is in the foreground and dominates or controls the conventional background.

When metaphor is situated in a predetermined convention the understanding distorts what is going on and our understanding of the situation. New perceptions can reorganize the meaning. All understanding comes via language and is related to previous experience. We make meaning of lived experience through language and perception.

When language informs perception we get convention or conventional creativity and when perception informs language we get invention and innovative creativity.

Metaphor is always situated in a real situation and a perceptual arena. The goal in a creative process is to set aside conventional understanding and get new understanding and perceptions. Knowledge accrues by going back and forth between convention and perception – in a figure ground gestalt and reversing it. Figure ground gestalts are always reversible. The figure controls the ground because the eye always sees it first.

Convention and Invention

The dialectic of convention refers to when language controls the way we experience perception. Conventional aspects of language are small, contained and controlled. They stop the flow of perception. Perception can take the arbitrary bits and bring them into the flow of language. When the dialectic of perception controls language we have the opportunity or experience of invention or innovation. Metaphor relates a known perception or experience to an unknown experience or perception via language. Metaphor occurs by bringing perception into conventional language and reversing the figure ground relationship. When convention informs perception ideas inform the creative process

and conventional forms emerge. When perception informs creativity then invention can occur.

Chapter 3:

The Art Therapy Process

A simple way to explain the therapeutic process is to consider four key aspects: emotional and symbolic expression, historicity, reclassification and reconstruction / re-creation. While they are essentially sequential in the sense that by the time one has completed therapy the artist/client will have moved through all of the stages, the process is not necessarily linear. In fact, the process will move back and forth through all of the stages numerous times.

Emotional & Symbolic Expression

The therapeutic session fosters the expression of feeling, the articulation of emotion and ideas, which among other things gives the client the experience of being heard, accepted and understood by another. The therapist in a very real sense acts as a container for ambivalent and disturbing feelings.

The expanding use of metaphor functions to expand consciousness. People often feel that there is a barrier between the describable and the indescribable, between articulate and inarticulate levels of thinking. Symbols and images can give form to these unformed feelings.

Symbol formation is a very important aspect of cognitive development in the human psyche. The development of symbol formation occurs through the use of metaphor. Similar to a map, art creates a narrative, a story, where many elements can be seen simultaneously. The art can be perceived as a map with a variety of charted symbols, signs, icons (image via resemblance), indexes (one thing varies) and symbols (arbitrary indicators, words). An example of an index would be changes in direct proportion to another, for

example, "where there is smoke there is fire". Perforated clay could function as an indexical record. An individual might have a difficulty in this area of recognizing symbolic expression i.e. the MOUTH of a river.

Due to its simultaneous nature, art in therapy can be of value when working with an individual who has a block in recognizing the duality that a symbol is both itself and the thing it stands for without being identical with it. The development and importance of symbol formation is beyond the scope of this chapter, but deserves considerable attention.

Historicity

The therapeutic session involves among many other things the more or less systematic exploration of the historical nature of the client's feelings, ideas and metaphoric renderings of his or her life situation to discover the reciprocal relationship between the past and the present. Associations are made to early family life, and to culture. For example, with First Nations people, it would be important to connect to the many facets of cultural interaction, racism, enforced schooling and so on.

Reclassification

As part of the process of reconstruction, "*Reclassification*" involves a questioning of the cognitive constructs (metaphors etc) that have been established to protect or defend the emotional life of the individual. This stage of therapy involves their subsequent reclassification in the light of cognitive error or their inadequacy to represent present conditions. This is a process of discovering various 'self statements' or beliefs, examining the roots of these ideas and the validity or current relevance of the statements. The sense of responsibility and blame that an individual who has been sexually abused feels would be a prime example. This process has much to do with the defense mechanisms or survival tactics designed to resist bringing to light the child within the adult.

Reconstruction and re-creation of the self

The therapeutic process involves a painful process of reconstructing the client's physical, emotional and cognitive life in the light of the

family and more general social dynamics. Initially there is a tendency to focus on the expression of key traumatic experiences but this gradually gives way to a more subtle and detailed examination of the client's current sense of identity and its formation in the light of historical antecedents and present constraints.

Reconstruction refers to the period in which the therapist and the client are involved in a reconstruction of the past and the links between contemporary and past experience becomes clear. The gaps in the memory of the client may pertain to suppressed memories and defensive reactions. Re-creating oneself through art and personal exploration can help to fill some of these gaps so that the continuity of experience no longer needs to be disrupted by neurotic defenses.

Creativity and the Reflective Process

It is important to remember that the creative process is different than the reflective or interpretive process. As soon as you start reflecting or analyzing while creating the creative process is circumvented. Experiencing and reflecting are two separate activities and we cannot experience something while we are reflecting on it. As soon as we start to analyze a feeling or experience we are no longer immersed in the experience of it. This occurs as one starts to look at the artwork in order to see what is to be seen. For this reason it is important not to ask questions regarding the artwork or creative process while the individual artist/client is engaged in the work itself. This is because the questions and reflections will change the nature of the creative process itself. Now as soon as I state something like that with some degree of authority I am reminded of times when this is not true or appropriate in a therapeutic process. In fact, there are times with children or adolescents when they might be involved in some intense chaotic discharge and the approach of the 'third hand' (Kramer, 2000, p. 47-69) could bring the process into a formed expression, which would be more ego-syntonic and lead to a more grounded and positive self-awareness.

Chapter 4:

A Hermeneutic Phenomenological Approach

This chapter discusses the key concepts of hermeneutic phenomenology in relationship to art therapy focusing particularly on providing a theoretical foundation for the training and supervision of art therapists.

Hermeneutic phenomenology can be applied to all aspects of art therapy: the materials, creative process, the client/artist, therapist and supervisory relationships. In being attentive to how things appear and wanting to let things speak for themselves, it is a descriptive phenomenology and it is an interpretive (hermeneutic) methodology in that all phenomena that presents itself as 'lived experience' is already captured in language and already meaningful and therefore interpreted. The process of interpretation acts upon the text, which is the focus of interpretation and it may also act upon the individual who is interpreting. Insight into the self may thus be revealed.

Hermeneutics is essentially the theory and practice of interpretation with the aim of understanding the writer or artist as well as or better than the individual understands him or herself. It was Schleiermacher (Messer, Sass, Woolfolk, 1988, p. 6) in his work on the interpretation of ancient texts that first stated that "the typical methods did not lead to a deeper understanding of the structure of literature from prior periods." He felt that it was important to consider the socio-cultural context and any particular factor that might influence or affect the writer researcher in the exploration of meaning. The focus on understanding the original intentions of the author became the basis for valid textual interpretation (Woolfolk, Sass, Messer, 1988).

In art therapy interpretation is aimed at eliciting and exploring the meaning emerging for the artist/client. This emphasis on the

importance of the "lived experience" as expressed by the individual's text or artifact is fundamental to the practice of art therapy. The focus on "life understanding itself" and the emergence of meaning for the individual in relationship to the world is a core component of art therapy. Creating art in a therapeutic context provides an immediate lived experience to be explored, which includes not only the thoughts of the artist client, but also their physical, sensory and emotional experience. Both the artwork and the creative process can be considered as text for exploring meaning.

Heidegger's hermeneutics is considered an interpretive phenomenology. For Heidegger, the focus of hermeneutic understanding is not simply to try and understand what the author of the text intended to communicate but he realized that the process of interpreting a text opened up the possibility of the interpreter being revealed by the text (Van Manen, 1990). This is very much true in art therapy. The process of exploring the meaning in the artwork and the creative process opens up the possibility of insight and understanding to be both discovered and created in the dialogue between the artist/client and the art therapist.

This possibility of being revealed by the text is both fearful and exciting. Artist/clients come into therapy to gain more self-understanding - with the desire to know and to be known. There is also the fear that if one is truly known that one will not be found to be acceptable. For many artist/clients there is the lurking fear of being too bad or too messed up to be loved. It is equally important for the therapist (student/supervisee) to approach the therapeutic encounter and dialogue with the awareness that he or she may also be revealed. In fact, many of the concerns brought into supervision pertain to the therapist/supervisee being unaware of or reluctant to look at the meaning being revealed not only for the artist/client but also for him or herself.

Gadamer's position regarding interpretation is that we can never separate ourselves from the meaning of a "text". It is my intention to include - not only writing in the term "text," but also the artwork, the physical body, life narratives, human action, situation and all of lived experience. Applying this idea to art therapy one would say that the therapist is an integral part of the therapeutic experience and the

very nature of the questions posed, responses reflected and meaning that emerges in the dialogue is as much a part of the art therapist as the artist/client. The art therapist's belief that meaning and essence will emerge and the seriousness of the endeavour contributes to the experience of the artist/client.

The hermeneutic circle was first described by Schleiermacher (Messer, Sass, Woolfolk, 1988) and applied to the process of interpretation. It refers to how in interpretation one cannot escape references to what is already known. Thus understanding will emerge in a circular manner moving from the relationship of parts to the whole and back to the parts. And all of these aspects are in relationship to the viewer/writer/researcher. This philosophic approach to interpretation has been applied to texts and to art. It does not mean that one can never understand a piece of art but it does mean that one can never understand it completely or rather that there will always be the possibility of more meaning to be discovered. This articulation of the process of how understanding and meaning can emerge is consistent with my experience of art therapy. Understanding and interpreting a work of art in therapy is an ongoing process, which takes time. As the therapeutic relationship deepens and more insight and personal history emerges interpretation of the creative process and the artwork gradually evolves and changes.

Basically, the hermeneutic circle is a term to describe the manner in which understanding emerges and refers to the contextual nature of knowledge. In considering the meaning of a sentence, for example, each of the words have individual meanings but those meanings will only clearly emerge in relationship to the other words. Thus the parts must be seen in relation to the whole and the context of the whole gives meaning to the parts. The same is true with artwork and with looking at the narrative of an individual's life. Thus this awareness of the relativity of meaning and the process in which meaning will emerge is integral to the development of an art therapist.

This circular pattern of interpretation is also referred to as a "hermeneutic spiral" because it moves from the parts to the whole and from the whole to the parts in ever increasing understanding. The circular exploration in art therapy pertains to not only looking at the text or artwork in this manner but it also explores the relationships. In art therapy these relationships are between the client and the artwork,

the client and the therapist, the therapist and the artwork. One only slowly approaches the truth of the situation and the truth will change as the contexts change.

The principles of phenomenological hermeneutics can provide an interpretive framework to examine the concrete nature of the art materials, the creative process and include psychological and clinical theory. A phenomenological exploration of meaning is always tentative - always incomplete. A 'lived experience' would never be viewed as universal or common to all humans, irregardless of culture, gender, or developmental stage. (Van Manen, 2002). This attitude of the phenomenologist is important for an art therapist. It is important to stay open to new meanings being revealed - never to impose an interpretation as fact but to use interpretation to shed light and provide the possibility of understanding and the development of new meanings.

In art therapy, as previously stated, I consider the artwork as a text, and as such it can "speak" to us. In using the vocative method in phenomenology, when we approach the artwork as 'text' we need to be open to both address and to be addressed by the art. Max Van Manen (2002) explains that the aim of the vocatio is to let things "speak" or be "heard" by bringing them into nearness through the vocative power of language. This notion of the vocatio has to do with the concept that a text can "speak" to us, and in art therapy, this would refer to the idea that not only can we speak to the art but that the art work can speak or address us.

There is a tendency when we speak to the artwork or about the artwork to stop listening to the object or artwork. The artwork can only speak if we listen to it and are open to being addressed by it. This means that we will not already know what it will give voice to. This is a very significant component of the phenomenologist's attitude that needs to be brought into the art therapy session and into art therapy supervision. The artist/client may be speaking about the artwork and the meaning they have attributed to it with a long narrative but may become more anxious to be asked to look at the art to see what is there. Likewise the therapist/supervisee may come into supervision with the intent of telling the supervisor what happened in the session as if it were fact and not their own interpretation of the session. Looking at

the art in supervision or creating art in supervision will often serve to bring the artist/client into more current awareness.

The voking act, which here refers to the speaking to and being spoken to by a text or artwork, provides the possibility to "know one's self", not in the narrow sense of narcissistic self- examination but in the sense of discovering existential possibilities, what it is to be human, what lies at the heart of our being and personal identity. The "call" signifies that we need the other, through whom and with whom we seek understanding (Van Manen, 2002). This need for others to reflect our sense of self is a key component in the therapeutic relationship. We have an implicit, felt or "pathic" understanding of ourselves in situations even though it is difficult to put that understanding into words (Van Manen, 2002).

Art and perception are integrally linked. Creating art is a direct experience. Looking at art and becoming conscious of it is another direct experience (Betensky, 1995). The art therapist needs to suspend a priori judgments about what should or should not be seen. They need to look with openness and to look with intention – to see - to perceive. Through the process of looking at the created artwork the artist/client learns to see all that can be seen. The structure, dynamics and meaning in the artwork can be explored initially through a description in detail of the artwork and then by connecting the metaphors to their inner experience and associations (Betensky, 1995).

As an object of study, the therapeutic modality of Art Therapy actually has the advantage of offering an intense lived experience - the creative process - and the possibility of reflecting upon this intense lived experience through entering into a dialogue with the artist/client regarding the artwork created. The creative process in Art therapy can take an individual through sensory and kinesthetic expression to perceptual and affective awareness on to cognitive and symbolic meaning (Lusebrink, 1990).

The Phenomenological Method

The phenomenological method fosters an attentive sense of wonder in the world while the hermeneutic practice continually aims at open-ended interpretation, the recognition of bias, and the relating of part to whole and whole to part. Phenomenology focuses on the

study of essences: one is always looking for the essential nature or meaning of the phenomena. In philosophy it is used to focus on the individual's conscious, perceptual and intellectual processes, excluding preconceptions and the idea of external consequences (Gregory, 1987).

Phenomenology is a philosophical method aimed at getting at the truth - it aims to achieve clarity of insight and thought while including the subject. It makes a distinction between appearance and essence. The three main features of the phenomenological method are:

- the attention to the description of the perceived phenomena;

- focus on capturing the essence;

- the essence is found by intuiting and not by deduction or induction.

Merleau-Ponty (1969) wrote "to look at an object is to inhabit it and from this habitation to grasp all things." He continues:

> the world is not problematical. The problem lies in our own inability to see what is there. The attitude of the phenomenologist, therefore, is not the attitude of the technician, with a bag of tools and methods, anxious to repair a poorly operating machine. Nor is it the attitude of the social planner, who has at his control the methods for straightening out the problems of social existence. Rather it is an attitude of wonder, of quiet inquisitive respect as one attempts to meet the world, to open a dialogue, to put him in a position where the world will disclose itself to him in all its mystery and complexity (p.12).

Phenomena are studied as they present themselves in consciousness as immediate experience. In the context of art therapy the artwork is to be considered a phenomenon with its own structure, dynamics and meaning. The creating of the artwork is also a phenomenon and the dialogue about the art either during or subsequent to the creating is also a phenomenon. The artist/client, the art studio environment, other group

members if in a group, and the art therapist are all each individually a phenomenon and the whole experience is a phenomenon.

Part of the art therapy experience is reflecting on the 'lived-throughness'. Lived-throughness is brought into the art therapy session by both creating art and bringing the narrative of past experience into the present. The lived-throughness of the creative process may, through speaking of it, produce a 'text'. The lived-throughness of the subject matter or content of the artwork pertains to past experience and feelings, which are present in the individual.

The 5 key concepts of phenomenology outlined by Merleau–Ponty in the introduction of Phenomenology of Religion (Bettis, 1969) can be applied to art therapy (Carpendale, 2002, 2006). These concepts are: description, reduction, essence, intentionality and world. Before I relate these concepts to art therapy I would like to speak briefly to the nature of this method. First of all, it is not a sequential process and does not have to follow a specific method - these five conceptual elements do not need to appear in any particular sequence, nor do they appear one at a time. Rather, they can overlap and interpenetrate one another much like a weaving. I tend to view these concepts in terms of a figure/ground relationship – when we bring one element into focus, it always appears against or as the ground of all the others. Thus when we speak of one element, such as intentionality, we are also speaking of the other four elements in context. These aspects can be related directly to art therapy and art therapy supervision.

Description

In this step we are looking for a pure description, not analytical reflection and not scientific explanation, and not tracing back to inner dynamics. Through the process of looking at the artwork and describing it the individual artist/client learns over time to see a great deal more than they saw when involved in the creative process. The intention in this process is to make a verbal translation of an inner experience through a description of the visual and not to explain, analyze or be seduced into a narrative. It is a return to the image, the creative process and the concrete nature of the artwork. The intent with this step is to look in order to see what is there. The therapeutic process is about

learning to look and to perceive. In the description one wants to get away from assumptions and interpretations.

The focus here is to achieve a direct contact with the world as we experience it not as we conceptualize it. In therapy one has to stay aware of oneself as the therapist – that one exists and is perceiving the subject and that any analysis needs to include the first sensations and aspects of the object/subject from different perspectives (we need to figuratively walk around and get a good look to get a good description. Merleau-Ponty tells us that, "the real has to be described, not constructed or formed" (1969, p. 17).

The Reduction (or bracketing out assumptions)

The philosophical ideas behind the reduction are kindred to the concepts underlying the teaching of therapeutic presence in art therapy. The reduction is not the end of the method; it is very much just part of the process of opening up to wonder and to an open ended attitude of curiosity in the mystery of existence. The significance of the reduction (bracketing) is the idea that we are looking to re-achieve a direct contact with the world as we experience it rather than how we conceptualize it. Reduction is more a way of being than an act itself. It is bringing in a thoughtful attentiveness. The intent of the phenomenological method is to come to understand the essential nature or structure of something and in order to do so we need to reflect on it and bracket out our assumptions. The art therapist can benefit from the phenomenologist's attitude of curiousity, open-mindedness, wonder and attentiveness.

Max van Manen (2002) writes on his website that:

> The aim of the reductio (the reduction or epoche, which refers to the "bracketing" of attitude in order to see) is to re-achieve direct contact with the world by suspending prejudgments, bracketing assumptions, deconstructing claims and restoring openness.

Therapeutically the first thing that one needs to bracket out is that there is a problem or at least a specifically defined problem. We want to put it aside for a moment and look to see more clearly what is happening. This involves bracketing out our assumptions, interpretations, transferences, counter-transferences, goals, and biases

to enable us to distill the essence. In fact, in some sense one is 'bracketing out' the whole question of existence in order to devote attention to the question of meaning.

In order to bracket out the assumptions it is important to consider what they are. Assumptions are often things that have been told to the art therapist about the client - this could include the diagnosis, the therapist's therapeutic approach, and the client, parents' and/ or professionals' interpretation of the problem and the client's own assumptions about his or her state of being. The process of bracketing assumptions can be helped by writing them down because if one doesn't go through a process of naming one's prejudices, biases, conceits, demons, pitfalls, interpretations, beliefs, values, therapeutic goals, work pressures, they likely will inhabit the therapeutic space or rather lurk around on the edges. This can happen especially when we experience difficulties or are concerned about how to proceed therapeutically. The process of the reduction may reveal health in other areas.

There are several levels of the reduction that have been outlined by Van Manen (2002). The first one is to return to a sense of wonder regarding the object of interest and to bracket the attitude of taken-for-grantedness. On his website Van Manen described the state of wonder as that moment "when something familiar has turned profoundly unfamiliar, when our gaze has been captured by the gaze of something staring back at us" (2002). The physicality and sheer presence of an artwork can aid in the possibility of this kind of attitude of discovery. It provides an objective other that is also a part of the self because the self has created it.

The reduction is about putting aside one's subjective feelings, prejudices and expectations. It is also about putting aside the clinical, psychodynamic or developmental theory that might come to mind. The intent of the reduction is to see with fresh eyes the actual lived experience of the artist/client that is not already defined and circumscribed by issues and themes. The eidetic reduction is about not being seduced by the intensity of vivid mental images in the artwork or narrative and being able to focus attention on the essence of lived meaning. The eidetic technique of "variation in imagination" refers to a process of comparing the phenomenon in question with other related but different phenomenon. What makes this experience - this piece

of art, this client, this situation or supervisee - unique and different from other lived experiences? This is where one is considering the relationship between the individual lived experience and the universal - iconic - essence - that does not pertain to the immediacy of the lived experience. This does not refer to a generalization of human nature or view of the collective unconscious. One is looking for an experience of meaningfulness.

Van Manen (2002) identifies the hermeneutic reduction as the aspect where we need to bracket all interpretation and attend to an attitude of openness. In order to seek openness one needs to reflect on the assumptions, theoretical frameworks and biases that colour the viewpoint. The focus of the reduction is to restore openness, to become conscious of prejudice and bias, to become aware of the subjective feelings and pre-understandings and to return to a sense of wonder via bracketing our assumptions.

The Essence

The term "essence" is derived from the Latin essentia, or esse, which means, "to be" and from the Greek ousia, which means the true being of a thing - referring to the inner essential nature of a thing. Essence is the core of the phenomena - that makes it what it is. Husserl (Van Manen, 1990, p. 10) referred to essence as the "whatness" of things, rather than the "thatness" of things. The whatness pertains to the essential being or nature whereas the thatness refers to existence itself.

"To seek the essence of perception is to declare that perception is not presumed true, but defined as access to truth" (Merleau-Ponty, 1969, p. 24.). We have perceptual experiences of the real as well as the imaginary. The world is already there before reflection begins. "Looking for the world's essence is not looking for what it is as an idea once it has been reduced to a theme of discourse; it is looking for what it is as a fact for us, before any thematization." (Merleau-Ponty, 1969, p. 23.)

Art can be viewed as holding or mirroring the essence of the art therapy session and it survives the session as a material object. Images hold the possibility of simultaneity, which is impossible in discursive or verbal communication. Looking at the art involves intentionality: looking to discover meaning to discover the essence. To learn from experience one must first have an experience and then become aware

of it and then think reflectively about it. It is not the cause or factual truth of the matter that one is looking for but rather the exploration of meaning and an understanding of the essence.

In the phenomenological method there is a focus on distilling the essence. This will include exploring the meaning of the artwork, the creative process and the being of the client. What is the core of the problem? What is in the art? What is the essence of the individual? In art therapy supervision there is the continued process of questioning the art in order to discover meaning. The intention of supervision is to seek the essence of the therapeutic experience.

Intentionality

The intentionality - the motivation for therapy generally focuses on the discovery or creation of meaning in life for the individual. The term "intentionality" refers to the interconnectedness of human beings to the world. It is a term rooted in medieval philosophy as being that aspect that distinguishes mental or psychical existence from physical existence. (Merleau-Ponty, 1969, p. 10) All consciousness is intentional in nature and in fact all thinking, which includes perceiving, imagining, and remembering, is always thinking about something. The same is true for actions, which are all intentional in that we listen to something or hold something or point at something. It is only with reflection that we are aware of intentionality because in an ordinary state of mind we experience the world as already made, already there. "All human activity is always oriented activity, directed by that which orients it." (Van Manen, 1990, p. 182)

All mental activity is directed towards an object – you can't think without thinking about something. Feeling is not pure – it is always directed or about something. (Merleau-Ponty, 1969, p. 11) Intentionality suggests that there has already been a "bracketing" of previous judgments or acquired ideas. When one is intent on what one is looking at the object of attention begins to exist more than before; it becomes important, it starts to mean something. There is an intentionality of emotion in relation to the object and a new aspect emerges, which is *meaning*.

The intention is not specifically to problem solve but to gain a deeper understanding, a glimpse at truth or the essential meaning of

an experience. As we become more conscious as a therapist we will perceive the essence of the therapeutic relationship and be able to respond intentionally and not unconsciously.

World

The human subject is being-in-the-world, being with others. The client can't be described or viewed in isolation. The artist/client is in the world – they have fellow group members, family, school, work, peers, therapist, and others. His or her social interests and interactions are in the external environment. Being-in-the-world or context would include the artist client's personal history, significant life events: illness, social/ family changes, losses, trauma, family structure (family of origin & present family), culture, and developmental stages. What are all the related factors? Listen for the gaps in the narrative. It would also include the supervisee's context and being-in-the-world. Are there transference or counter transference dynamics?

Conclusion

There is a dilemma in the art therapy world regarding the idea of symbolic interpretation of the art. There are those that are adamant that it is only the artist/client that can interpret and there are those who will make assessments and interpretations of the symbolic content, style and process. Many art therapists are taught to be extremely careful not to impose interpretation on their clients. An underlying premise is that it is important for the client to interpret his or her own art. There is no doubt as to the value of the client's own insight and discovery of the significance of their artwork. In reality we all are interpreting life, people, and art, all the time. We may not be that aware of it. Therefore it is important in training to become cognizant of our interpretive assumptions.

How can the hermeneutic phenomenological method shed some light on this dichotomy? Interpretation needs not to be considered as a dirty word. Does the anxiety regarding the possibility of interpretation pertain to the anxiety of being revealed and the thought to be 'dirty' or 'disordered' aspects of the self will be revealed. Anthropologically dirt can be thought of as matter out of place. (Douglas, 1966) Perhaps it

would be appropriate to consider the social construction of metaphors of clean and dirty or light and darkness.

But how does insight and interpretation come to light? Insight can occur as the artist/client is involved in creating the art and when he or she enters into a dialogue with the therapist about their art. Art therapists have conscious or unconscious interpretive frameworks, which give direction to their questions, frame their clinical responses and set a tone for their reflections regarding the artwork. The problem is how to teach openness towards interpretation while communicating the need for restraint concerning certainty.

The hermeneutic phenomenological method applied to art therapy considers both the art, art making and the writing as text. The focus is to reveal the text and through the process to be revealed by the text. It holds that meaning will continually emerge and that there will always be the possibility of new meanings. It is the attitude of the phenomenologist that we are trying to achieve in the training of art therapists. to cultivate an openness to interpretation and a restraint against certainty. The ability to perceive and describe with openness and wonder, the ability to describe without explaining, judging or making assumptions, the ability to look with intention and to consider everything in context and relationship, and to intuitively distill the essence are all important therapeutic qualities. For an art therapist this method can be used in the therapeutic session, in the process of reflecting on the session through writing and art making and in supervision.

Max Van Manen (1990) writes that

To do hermeneutic phenomenology is to attempt to accomplish the impossible: to construct a full interpretive description of some aspect of the life-world, and yet to remain aware that lived life is always more complex than any explication of meaning can reveal. (p. 18)

Phenomenology has been a philosophical method that has used writing as its mode of inquiry. I would suggest that art therapy provides an opportunity to use not only writing but to also include engaging with the art and the creative process as text. To write is to draw us in through words. Writing in a phenomenological inquiry is based on the idea that no text is ever perfect, no interpretation is ever complete, no

explication of meaning is ever final, and no insight is beyond challenge. (Van Manen, 1990)

To study consciousness one tries to reduce the perception of phenomena to its essence. Applying phenomenological attentiveness to the creative process of self-expression can lead to the possibility of self-discovery and insight into the essence. In a phenomenological approach to art therapy the specific phenomena of creating artwork can be studied consciously as an immediate experience as well as looking at the artwork.

The use of the philosophical phenomenological method can be inclusive of all the interpretative frameworks because all of what is perceived, thought, and felt is considered phenomena. The focus is on distilling the essence by the process of reduction while taking into account intentionality and context.

Chapter 5:

Interpretative Frameworks

In art therapy there is a wide range of interpretative frameworks stemming from the variety of therapeutic practices. In addition there is a wide range of interpretative perspectives in art history. Despite all these variations there is a commonality, which pertains to the use and significance of the creative process, the tangibility of the artwork and the healing intention of the therapy.

There are advantages and disadvantages to any theory and it is my belief that no one framework is capable of being the only one. There are many points of view and different approaches to art therapy: Freudian, Jungian, Gestalt and object relations to mention a few. But underlying them all is the creative process of art therapy and the creative process of being a therapist. One can speak of the "art" of being an art therapist.

There is a dilemma in the art therapy world regarding the idea of symbolic interpretation of the art. Questions regarding interpretation often emerge. Is it necessary? Isn't the art making process healing by itself? Is an interpretative framework necessary? Who should interpret? In some schools of art therapy interpretation has developed a bad name because there is a fear that interpretation will be reductive and has the potential of 'abusing the image' or that the therapist might impose an interpretation.

In my view interpretation is not a dirty word. There is a question however, of who interprets and how they interpret. The reality is that we all are interpreting life, people, the human dilemmas, the arts and culture all the time. We just may not be that aware of it. Therefore, it is important in training to become conscious of our interpretive assumptions.

It is necessary to understand the theoretical and interpretive framework being used. A theoretical framework is valuable for illumination, to see in the dark, to see beyond the moment. It is important to provide illumination. The reality is that we all have theoretical frameworks operating at all times, whether we are conscious of it or not. It is necessary to be aware of them and to be flexible with different concepts.

Every theoretical framework carries with it both the ability to make visible and to obscure, to see and not to see; every insight may also leads to blindness about something else. One needs a framework of understanding to interpret what occurs. One cannot interpret one thing or another except within the context of a more or less congruent theoretical model. Very often, however, a therapist may not spell out their interpretive framework. This means that there are hidden or implicit assumptions, which govern interpretation. Problems arise when these assumptions conflict with each other or when they involve biases or prejudices of the therapist which may be detrimental to the client's well being or to the therapeutic process.

Many art therapists and art therapy students are taught to be extremely careful not to impose interpretation on their clients. They are taught that it is important that the client interpret their own art. There is no doubt as to the value of the client's own insight and discovery of the significance of their artwork. However, there is the question of how this comes to light. The reality is that it happens during the creative process in an internal dialogue with the artwork and during the reflective process in dialogue with the art therapist.

The art therapist has an interpretive framework, which gives direction to their questions, frames their clinical responses and sets a tone for the reflections regarding the artwork. Artwork can be very evocative and it is important that the therapist not make assumptions regarding specific meanings or interpretations. Initially, in training art therapy students we teach them to edit out their assumptions and interpretive remarks. The benefit of looking at the artist/client's artwork in supervision is that more possible interpretations can be explored. It is important to develop skills in perceiving symbolic and metaphoric components. Practice is needed in seeing the range of potential interpretations. Looking at the art in supervision is a safe way to develop skills in exploring metaphors,

elucidating symbols and practicing a phenomenological unfolding of the images in the artwork.

What do we get in touch with in the art?

a) Feelings: there is a need for an outlet of painful and intense feelings and if they are expressed in the art it tells what the artist/client is ready to look at and deal with.

b) Memories: the art approach to therapy tends to bring back more memories to consciousness and this enables one to fill in the emotional gaps in one's life. A house can't be built without foundations or materials.

c) Impulses: Various impulses kept out of awareness appear and want to be dealt with. Aggression is a predominant affect, which is often repressed.

d) Fantasies: Once you can bring to light certain issues it is like finding a sunken treasure. The therapist is in a position to facilitate this process of recovery and help the individual understand how symptoms or personality traits are derived from attempts to cope with external stresses and internal conflicts.

The skill of the therapist is in creating an emotionally safe environment and asking the right questions in response to the art and the individual's comments. There are many different ways to approach looking at the art and exploring meaning. One can take the drawing as a conversation piece and encourage the individual to make a translation from the visual to the verbal.

The therapist may plant seeds of insight and mirror the acceptance of feelings. This is important, as it is not what a person feels about something that is the problem, it is how they feel or think about their feelings that have implications in terms of emotional behaviour.

It is important that the therapist be aware of his or her own reaction, as the therapist's own feelings can provide clues to the emotions and issues present. The art can be very evocative. Through the difficulties

of art expression and communication be aware of discovering commonality. Sandra Butler (1988) speaking at a conference on sexual abuse said that, "If you realize that you have more in common than not, it is hard to make a major mistake." The cure or growth is the individual's responsibility. A good therapist is one whose clients leave feeling empowered and able to better understand his or herself.

The Structure of Interpretation in Session

The making of art for the most part involves the interaction of the individual artist and the art materials. The audience for which the art is made (the world) remains at a distance. With art therapy, on the other hand, the audience, in the person of the therapist, is present during the creative process and in reflecting on the artwork. There is an active three-way process. In this sense, Art Therapy is closer to the traditional role of artistic or symbolic expression in the context of healing because art is not divorced from either healing or the social context within which it is expressed.

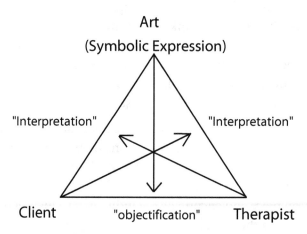

Each of the three positions on the triangle "mediates," reconciles or transcends the polarity of the other two positions. Thus the art expression itself mediates between the client and the therapist. It is the very matter of their communication with each other. It involves the objectification of the interior life of the client thus making it available for both interpretation and reconstruction in dialogue with the therapist. On the other hand, the client's interpretation of the art and its relation

to him or herself mediates between the therapist and the symbolic expression. The therapist must certainly take this understanding into account in the interpretation. The client is, after all, the one most likely to know the local and historical symbolism involved in the art. Finally, the therapist's interpretation and questioning mediates between the client and her symbolic expression, revealing and transforming its meaning and its hidden unconscious roots.

Art therapy is thus a three way process involving the dialogue between therapist and client by way of the artistic expression itself and the interpretive understanding of the expression. Art therapy, like all contemporary therapeutics is aimed at the re-integration of the personality in the context of the social environment.

Certainly, symbolic expression itself has a healing quality and performs an inner transformation in the process of art making. Art is never an exact reproduction of inner feeling; the inner conflict moves / shifts/ changes in its expression through the art making. The art bridges the emotions and intellect. Human beings are meaning–giving, meaning-seeking beings. In the symbolic expression we have a sense of what is missing, so to elucidate its meaning we have an interpretative model, which both includes and excludes what is considered relevant. In the arts, meaning is presented in an indirect way; there is a double meaning. First there is the immediate sensory experience, which has a 'surplus' of meaning and, second there is a symbolic residue, where the meaning is not immediately apparent.

Dialogue: Questions and Interaction

Initially one can ask: "Would you like to look at your art?" "Would you like to talk about it?" There must always be a choice to speak or not to speak. Very often the invitation to speak leads to a personal narrative regarding both the art product and the art making process and the individual themselves. If an individual would like to explore their art but is uncertain as to how to proceed, one can initiate a process whereby different levels of meaning to each piece of art can be explored.

I have found it useful in training art therapists to identify three different categories of questions and responses to artwork. They are the concrete, metaphorical and self-reflective. If uncertain where to start or in the beginning of a therapeutic relationship it is always best to start

in the concrete and move slowly into the metaphorical. Some artist/ clients move directly into the self-reflective or the therapist may have given an art directive that has focused on the self-reflective. Then it may be important to move back through the metaphor questions to the concrete to provide some grounding for the emotions emerging.

Concrete

Concrete questions are questions that ask directly about what is perceived in the artwork. The therapist encourages dialogue regarding the specific content of the picture to clarify the created image. They might ask to have the picture described, ask about specific elements in the art and about what is happening in the picture. The therapist looks at what is included in the art, moving from the general to the specific, looking at what the picture contains, clarifying the model.

For example: "What are some of the unusual and interesting things you see in this picture?" "Is there a story in the picture?" "What do you think it might be?" "Are certain things repeated in the picture?" "Is there a pattern?"

Metaphor

Metaphoric questions are questions that elicit responses regarding the underlying metaphors, the emotional tone or mood, and the relationship between elements or aspects in the art. This level of questioning begins to explore the feelings and associations expressed in the art.

For example: "Is there a special mood or feeling to the picture?" "How has the artist expressed that feeling?" "Does the space feel open or full?" "Is it crowded?" "Is something missing?" "Are there shadows?" "Is the picture dark or light?" "Where is the light source in the picture?" "How has the artist paid attention to texture?" Symbols could be amplified.

Self-reflective

Self-reflective dialogue and questions wonder about the relationship between self and the significance expressed in the art. This is the part of the therapeutic process whereby the significance of the metaphor and images expressed in the art are related directly to the individual's experience of self. One looks at the relationship between the client and the art, the congruencies and incongruencies, the inclusions and

exclusions. The goal is to identify key issues through self-understanding. For example: "Do any of these feelings relate to any aspects of your present life?" "Can you carry yourself in to the picture?" "What do you see?" "What do you feel? Think?"

A note of caution

A basic ground rule is to first of all explore the concrete and metaphoric levels intensively. Wait until the individual moves into the self-reflective aspect, or ask if he or she would like to take the exploration into the self-reflective level. Having said this, I think that you will find that generally speaking adults will easily move into the self-reflective aspects – this is why they have come into therapy. There are also specific directives, which focus on the self-reflective aspects such as self-maps and inside outside boxes.

What do you see?

Mala Betensky (1995, p. 17) suggests always starting with a question of "What do you see?" This is after the artist/client has had an opportunity to look at the art and quietly reflect. This question emphasizes that it is what the artist/client sees that is important – not the art therapist's perceptions. It also is asking the artist/client to look at the art and see what is there - not to just speak of the narrative or intentions that were present in the creative process.

Betensky believed that often individuals require some help "to learn how to look in order to see all that can be seen in their art expression." (1995, p. 6) The phenomenological method starts with a verbal description of what is actually seen. This may require 'bracketing' previous judgments or acquired ideas. The therapist needs to suspend apriori judgments about what one is supposed to see, to look with openness and to look with intention – to see, to perceive. The artwork is viewed as a phenomenon with its own structure and the individual learns to see all that can be seen. The artist's verbal description is integral to the process. After the detailed description of the structure, the artist then connects the artwork to his or her inner experience. The intention is to create a process of self-discovery through creative self-expression. To study consciousness one tries to reduce the perception of phenomena to its essence.

'Phenomena' refers to everything that can be perceived and observed with our senses and our minds. They are visible, touchable, and audible: thought, sensations, feelings, dreams, memories, and fantasies. Guided by an art therapist into intentional perception, clients may learn to see their art open up new possibilities, at the same time as having their natural vulnerability honoured by the therapist.

For most adult clients it is beneficial to have silence during the art making and looking at the art initially, as words are also phenomena and may need to be bracketed out. The role of the art therapist is to encourage the client to sensitive looking and to accurate seeing.

Interpretive Focus: What do we look at in the art?

The therapeutic relationship contains many distinct elements including the client's verbal and non-verbal communications both to the therapist and to the artwork during the creative process Some of the following focal points have been adapted and expanded from Greg Furth's (1988) book '*The Secret World of Drawing.*' I have intentionally not given any specific meanings in relation to these aspects because I want to emphasize that they may have different meanings for each individual. It is important that the therapist stay aware of the multitude of levels and aspects for exploring artwork but it is not important that they explore every single aspect for each piece of art. These areas are intended as a guideline for how to look at the artwork and creative process (and may include some or all of the following aspects).

Emotional mood or tone

The art will express an overall communication of feeling and emotion to both the client and the therapist. When the emotional mood articulated by the artist/client is also seen and felt by the therapist it is considered to be "embodied art." (Schaverien, 1990, p. 86)

Meaning and emotions should be viewed on a continuum – to see metaphors as always having a dialectic. For example, when an artist/client speaks of that being a time when they were "happy" that it is being compared to times that were "unhappy".

Movement & dynamics

This can include style and motion or direction in the picture. One can also be looking at the line of trajectory that the eye follows of

movable objects in the image. Unconscious feelings may be indicated by looking at the directions where weapons or objects are pointed in the image and by determining the consequences. Consideration is given to aspects moving on or off the page.

Movement and dynamics includes aspects like the application of the brush stroke to see the direction the stroke is moving, the amount of paint on the brush or style and intensity of the brushwork. The energy and dynamics of the artwork may reflect the artist/client's character or intensity of emotion.

Repetition

Significance may be connected with the number of objects in an image. Repetition might also pertain to images of the self, colour or shape. Considerations of repetition would be in both the individual piece of art and over a series of works of art. Repetition may also indicate underlying transference dynamics. The repeated numbers may reflect the numbers of family members, either current or, more likely, family of origin. Or the numbers may indicate a significant time or age in the artist/client's life.

Natural imagery and the environment

Observe the natural formations and patterns of growth depicted. Some of the dualities to keep in mind are: cultivated or uncultivated environments, wildness or quietness, distant or closeness, exotic or familiar.

Keep aware of context like the relationship between objects in the immediate environment in the image. Looking at trees, one might consider the kind of tree, its size, shape, fruit, function, broken branches, knotholes or injuries to the tree. Where it is placed in the world and in the image would also be important. The experience and sense of landscape is connected to our sense of space. A landscape montage can be used to explore a sense of self. I have heard a Japanese art therapist speak of how they emphasize the natural landscape in art therapy.

Congruence and incongruence

What is odd or different? What is realistic? The therapist looks at the art, compares it to the surrounding world and considers whether things are out of season or out of context. Is the developmental level of the artist reflected or congruent with their artwork? If not, then does

it reflect an emotional or cognitive disruption in their development? Does the artist/client think it is odd or incongruent?

Presence and Absence

The therapist needs to keep in mind: the distractions, the disguises, and the defenses of the artist/client? And to consider what the artist/client chooses to relate or not to relate? There are certain things which are included, and certain things which are excluded, filled in or empty. Consider the use of white space. In Chinese painting the white space is considered either or both the void and the place of the spirit.

Figure & ground relationship

What is in the foreground or in the background? How do they relate to each other? What happens when the focus moves from one to the other? Certain aspects have been brought to the foreground and certain aspects are left in the background. It is important to look at what is valued and considered relevant or irrelevant. The art therapist must always keep track of the figure/ground relationship and the relationship of the narrative to the context. This is particularly important regarding cross-cultural issues or different social classes. The artist/client's context may be quite different to your own.

The use of space

The use of space is significant in an image - the feeling of emptiness or fullness on a page. We can look at the empty spaces. The placement of images or objects may be significant. Are they at the top or bottom of the page, central or on the periphery. Is the movement on or off the page? Who is left out of the picture? What has been excluded?

Abstraction

Here one might look at defenses, dynamics, movement, colour, shape and intensity. A title might be significant. The description of the creative process may hold relevant metaphors. The phenomenological description of the image by the client or possibly by the art therapist may reveal unconscious metaphors.

Colour

It is important to consider the colour correspondence to the perceived world in terms of congruence and incongruence. The

symbolic significance of specific colours designated by the client will be significant. Colour may be used for concrete expression or for emotional meaning. Colour may have individual meaning or cultural significance. Always explore the meaning that the individual artist/client gives. Don't make assumptions.

Size and Shape
Distortions in object size or shape and extensions on forms or erasures are relevant. Consider the sizes and shapes in relationship to other parts of the image.

Intensity
Intensity of the mark making (shading, underlining, pressure of tools, body posture, etc.) may be indicative of the emotional content as might edging or shading.

Boundaries
Boundaries may be present barriers, dividers, separations, enclosures and framing. It is important to explore how they function: to protect, to isolate, to contain, to keep in or to keep out. This might be indicated by the use of two sides of the page. Look at encapsulations - lines that surround or outline to create boundaries between objects or aspects of the image. How does the ground or base line appear? The sky? Consider the boundary of the page. Is it ignored? Kept inside of? Does it fail to contain or frame? Does it trap or restrict? Is it open and flowing?

Perspective
The perspective might be significant. Where is the viewer or artist situated? There might be a singular point of view, multiple points of view, a confused point of view or a bird's eye view. A child's perspective might include x-ray images, fold ups or an intellectual perspective. This means the inclusion of all the legs of an animal because we know the animal to have four legs, not because four legs would be visible from this point of view. These different perspectives might have specific meanings or implications in terms of the individual's cognitive development.

Narrative & words

Language and words may be included in the art. This may include words in collage, graffiti, cartoons, or as poetry. The narrative or verbal translation includes all of what the individual speaks of in regards to their artwork. This might include story telling or creating a fairytale.

Transparency

Transparency refers to things like overlapping images or x-ray images seen through a wall or a baby in a belly. Some artwork has many overlapping layers and sometimes images are covered up and then the surface may be scratched to reveal underlying imagery.

Symbolic content in the images

Aspects in the art may have a correspondence to the world; they may fall into the category of symbols. A sign or symbol may signify a number of different aspects:

a) Personal meanings: the individual's associations and memories

b) Social meanings

c) Cultural meanings

d) Biological or scientific meanings

e) Psychoanalytic or psychological meanings.

Process & use of the art materials:

Here we might consider the sequence of image making, choice of materials and method of applying them. Everything is considered significant but nothing should be seen as conclusive. The therapist should maintain a position of Socratic ignorance. The significance will be the interplay of these elements as they are explored and interpreted by the individual.

Chapter 6:

Therapeutic Presence

In this chapter I will first of all discuss key concepts regarding therapeutic presence and then I will discuss some of the significant metaphors pertaining to the essence and attitude of the art therapist. These metaphors will be discussed and then a variety of art and reflective activities will be outlined for more in depth personal exploration.

There is a great deal that has been said about the significance of the therapeutic presence of the therapist. The qualities of authenticity, congruence, empathy, and acceptance have been well articulated by the humanistic theorists with a focus on the self-actualizing of the client. I have also already noted the importance of the attitude of a phenomenologist – the openness, curiosity and ability to tolerate not knowing and letting the meaning emerge. For the sake of simplicity there are three key aspects of therapeutic presence that I like to emphasize and explore: respect, acceptance and faith or belief in the client.

Respect

Respect for the individual artist/client is integral to the therapeutic process. Respect includes respect for the artwork and the creative process and can be expressed in the way that you handle the art and view the art. The art may be experienced as an extension of the individual who may be deeply invested in their art and creative process. It is important to create a therapeutic environment that provides a warm, friendly, respectful atmosphere and to treat each artist/client as an honoured guest needing a healing sanctuary or sacred space. It is also very important in the therapeutic context to be respectful of the individual's strengths, coping skills, motivation and ability to get help.

Artist/clients are likely to feel very vulnerable regarding their difficulties and asking for help and support.

Respect in the context of therapeutic presence includes many aspects:

- Assure respect and confidentiality.

- Listen and give your undivided attention to the artist client. Do not have interruptions or distractions in the session. Attentiveness will communicate more than any specific words.

- Speak with courtesy.

- Listen closely to both the verbal and non-verbal communication. Be aware of cultural norms and the various aspects of non-verbal communication, such as: body language, physical closeness or distance, and tone of voice. The amount of eye contact may be too much or too little depending on the cultural background of the artist/client. For example, aboriginal or oriental artist/clients may give a light handshake or restrict eye contact as a culturally respectful way to be.

- Respect the individual's defense mechanisms and work to strengthen the ego and to understand the need for defenses.

Acceptance

Initially the therapeutic alliance is to be stressed: trust and confidentiality must be established. The best protection against being too intrusive in the beginning therapeutic situation is to stay within the context of the art associations. The therapist's skill and depth will be reflected by their ability to hold and tolerate the individual's unacceptable feelings. It is important to accept all of the artist/client's emotions, not expecting him or her to be different or feel differently.

Acceptance in the context of therapeutic presence includes many aspects:

- Emotions: Recognize the feelings the individual is expressing and reflect those feelings back in such a manner that the individual has insight into his or her behaviour.

- Artwork: Accept and honour each piece of artwork. See the art and the creative process as a whole expression of the individual.

- Stay aware of the whole: Be careful of not getting caught or trapped in a picture by focusing on one aspect and losing sight of the whole. A picture may have a meaning other than the one that we see. The whole here includes the art, the art making process and, most importantly, the individual and his or her inner world. This also includes the therapeutic space & process itself, which is itself only a part of the larger community. It also includes being aware of the individual's cognitive and developmental level, and being sensitive to losses and trauma that may have been experienced.

- Narrative: It is important that the art therapist beware of the potential of getting lost in the narrative or details of the image. This is when a therapist focuses so intently on the words that they lose the overall meaning. Just as a pianist focusing on his fingers can paralyze his movements. One can be reconnected by looking at the art, at the sentence or at the music. "It is not by looking at things, but by dwelling in them, that we understand their joint meaning." (Polyani. 1967, p. 18)

- Assumptions: Therapeutic questions or comments made by the therapist may very easily contain assumptions that the client may feel the need to fulfill. In this way, the therapist may unconsciously guide a whole session. Questions, comments, and suggestions should be open ended. If you praise one child's work another will feel devalued, and will perhaps try to copy the other's work.

- Dialectics: It should be remembered that any concept might imply and hold its polar opposite. Thus a concept of "art" implies a concept of something being "not art"; a concept of the beautiful may imply a concept of the not beautiful or ugly. E.g. If a comment is made about how beautiful a certain part of a painting is, there is the implicit comment that other sections of the work are not beautiful. Or in another example, a therapist seeing a picture of a birthday party or of Halloween may by their response assume that this was a pleasurable event when indeed it is quite possible that it was not. The therapist must be very sensitive to this sort of nuance. Questions and comments should for the most part be open ended.

- Positive regard: Accept each individual as they present themselves; do not expect them to be different. Offer each artist client your unconditional positive regard.

- Permission: Establish a feeling of permissiveness in the relationship so that the individual feels free to express his or her feelings completely.

Faith

It is important to have faith or the belief in the artist/client's ability to heal and come into balance. Respect the individual's ability to solve his or her own problems, when given an opportunity to do so. There are some life situations that cannot be changed in the external circumstances – the only part that can change is the individual's attitude and internal perspective. The Navaho people see healing as returning to a place of harmony where one can walk in beauty.

Faith in the context of therapeutic presence includes many aspects:

- Tolerance: It is important that the therapist can hold and tolerate the individual's painful and (what may be thought to be) unacceptable feelings.

- Creativity: Be aware of your own concept of creativity and the process of change. A picture may have a meaning other than the one we see. Interpretations may be experienced as intrusive and a violation of privacy. It is important to understand the assumptions on which you base your beliefs and values. We all have interpretive frameworks whether we realize it or not.

- Client centered: Follow the individual's lead, without directing the conversation or action. Don't hurry their process or creativity, or fill the space with talking about yourself.

- Timing: Stay aware of time in relationship to the whole therapeutic process, time in relationship to the present session and time in relationship to the whole creative process. Travel the journey the individual needs to take. Acknowledge stop signs and diversions. In later sessions you may come back to something that was indicated in an earlier painting.

- Space: Be aware of the sense of space in the art and in the dialogue. It is not necessary for the therapist to share all of her ideas, raise all the possible questions, or explore all the possible interpretations. Creative art should be a time of providing an opportunity to learn, discover and create. Be aware of the sense of space in the art and dialogue.

- Listen, observe, and wait. Don't bombard with questions or comments; in fact, many children and adolescents abhor questions. Remember that the individual is there to become more aware of his/her problems, to discover the meaning of their own experiences and come to terms with how to more creatively interact with their concerns and world. If we as therapists only had to inform clients of their problems and offer solutions we could simply write a recipe book for happy and successful living. The therapist must examine his or

her own need to talk or interpret. Does it have to do with the therapist's desire to be a wise teacher, a good therapist, or a need to heal and to be helpful.

- Reflections: Reflect and research the symbolic content and meaning with the individual. Listen, observe, and wait. Within reason, don't interrupt their flow in either the art making process or the ensuing dialogue.

- Responsibility: Remember that the responsibility for healing, creativity, growth and change is theirs. The healing is the individual's own work. It is the therapist's responsibility to create a therapeutic environment where self-reflection and healing can occur. Your responsibility is to create a space, an opportunity, a sense of safety, a respect and acceptance of their feelings and experiences.

Therapeutic presence

There are some key attitudes and ways of being that the art therapist needs to be aware of. It is most important for an art therapist to be congruent and present in the moment. I have a saying that refers to this "Do what you are doing when you are doing it." This refers to giving your undivided attention to the present moment.

During the art therapy session while the artist/client is making art, the art therapist – generally speaking – sits quietly with a diffuse gaze – observing in a meditative state – but not staring or being intrusive in any way. It is best not to interrupt while they are making art – within reason. Sometimes the art therapist will create art with the client in a conjoint or co-creative process and sometimes they will create art in a parallel play process. Generally speaking, this is more common with children and adolescents. However, the art therapist creating art in a client session needs to be very aware of not getting lost in his or her process and not to be making art for his or her own needs

Focus on the artwork can function to break down the power dynamics of the therapist/client relationship, a concern which feminist

therapy addresses. Because clients are in control of the creative process, and interpret their own work, they learn tools for healing themselves.

Diagnostic interpretation can be anxiety provoking to clients as they may feel if they draw then they will be completely exposed to the therapist, vulnerable to therapists being able to read their mind. It may reinforce the feeling of being "sick" and "bad". It is important to remember the uniqueness of each individual expression; his or her relationship to his or her own life experience will be unique. This is not to say that one should approach the artwork blind, but I can't over emphasis the power of the art. It can be very stimulating and evocative. One must carefully research the meaning, not impose meaning.

Art Therapy Training Group

Sensitivity to the painful and difficult process of therapy is best achieved through personal experience. The more conscious you are about your own feelings the more able you will be to accurately reflect and mirror the clients' feelings. It is important to be aware of one's personal beliefs and assumptions regarding health and the process of change and healing, as they will impact on the interpretive framework you bring to the therapeutic relationship.

Very briefly, transference and counter transference refer to how the therapeutic relationship between the therapist and the client is placed in the context of all previous relationships for both. Transference is a phenomenon whereby the feelings originating from the family of origin are projected onto contemporary relationships. Attachment, separation and fears of abandonment are often core issues. Counter transference refers to the emotions the therapist experiences in response to the client. To become more aware of the impact of transference and counter transference it is very important for the art therapist to experience the art therapy process in depth themselves.

Art is very evocative and it is important for the therapist to be conscious of and able to distinguish between his or her own emotional and metaphorical responses and those of the client. It is very important for art therapists in training to go through an intensive art therapy process themselves. Ideally this occurs in an art therapy-training group, which includes theoretical and therapeutic knowledge with a personal art therapy process. All aspects of art therapy should be included in

the training group experience such as art reviews and personal case studies.

The intention is to enable therapists to fully embody their understanding of art therapy, responding theoretically with knowledge that is integrated into their being. The aim of the therapist's own analysis is to enable him to sustain his feelings as opposed to discharging them like the patient and, conversely, not to produce interpretations on the basis of a purely intellectual procedure. The art therapist Greg Furth states: "Before a therapist can effectively help a patient with the symbolic language of his unconscious the therapist must open the closet of his own unconscious and become acquainted with its contents." (1988, p. 101)

Use of Personal reflection

A teenager once said that she thought that I could "mind read" because she felt so well understood by my reflections. She asked how did I do it and could she learn how?

I spoke of listening closely to what she said, how she said it and how I also paid attention to my own feelings and responses. Then I would hesitantly wonder out loud how I imagined she felt by how I would have felt in her shoes. When she was talking I was aware how she was projecting all of her feelings outside of herself into taking care of others; she was meeting their needs in hopes of getting her own met. I attempted to help her dialogue between her fantasy of having a good mother that would give to her and the reality of her mother always asking to be given to. Her need to be loved and accepted was so great that to be needed or wanted felt somewhat similar. Her experience in therapy was of being accurately mirrored; thus her impression was that I could mind read. I simply gave her what she had deserved all her life - my complete undivided attention and acceptance of all her feelings. The more conscious you are of your own feelings the more empathy you will have for your clients and the more ability to accurately reflect and mirror the client's feelings.

Art Activities & Reflective Exercises

Centering

Reflective questions: Contemporary therapists talk about the importance of feeling centered or being in the center of oneself. What does this mean to you? How does it feel to be centered? Be specific. How does it feel in your body, in your mind? What does the metaphor of centering mean for you? How can you tell when someone is centered? What could help a client be centered? What are the benefits of feeling centered?

Now think about the opposite: What would un-centered look like? How does it feel not to be centered? How could this affect a therapeutic session? Are there negatives to being centered? To be off-center: What does that mean? Do some people not want to be centered? What about the positives? Are there any benefits to being un-centered? Expand these ideas with language and elaborate: self-centered, off center, in the center, concentric, eccentric.

How can this be seen in the art? Where are the pieces within the art located? Are they centered? Balanced? Are they off center? What is the significance? How does the art relate to your client? Are they demonstrating and reflecting centeredness in the art? Are you centered while looking at the art?

Developmentally, it is likely that feeling centered comes from a positive experience of being held and handled as a baby and child. Reflect on your own sense of being centered. What were your initial experiences like?

Exercises

1) Create art reflecting on the concept and feeling of having a 'center' and being 'centered.' Express and explore your feelings and ideas, and most importantly the experience 'being centered'.

2) Look this word up in a dictionary. Try more than one dictionary. Research the term's etymological roots. Where did this word derive from? Is the dictionary term different from how it is used in conversation today? How has it changed?

3) Read Rudolph Arnheim's theory about the balance and center in art in Chapter 1 of *Art and Visual Perception: A Psychology of the Creative Eye.* (1974)

4) Create a mandala on a round piece of paper. Try one starting at the inside and working out. Try another starting from the outside and working in.

5) Take a ball of clay and close your eyes and let your hands create a bowl or container.

Grounding

Reflective questions: Therapists refer to the importance of feeling grounded. What does that really mean? How does that feel to you? How do you know when you are grounded? What image comes to your mind when you think of feeling grounded? Earth? Roots? Connections to the world or mother earth? How do you experience grounding in everyday life, with family, friends and in the world? What is so important about being grounded?

The obvious metaphor of grounding is the ground, but how does this relate to your concept of grounding? What metaphor comes to your mind? Grounded like a tree? Grounded like a plane? Some metaphors of grounding are negative. How could this affect a discussion about grounding with a client? What could be unpleasant about grounding? Grounded from going out on the weekend?

We know what the benefits of grounding can be for a therapist, but are there some people who would not want to be grounded? How does it feel to be grounded while trying to be in motion? How can you notice when someone is ungrounded? What does that feel like to be ungrounded? What could happen if grounding was absent in a therapeutic session?

How can you see a reflection of being grounded or ungrounded in the art? Is there a ground or baseline? Or are the subjects floating and ungrounded? Are they planted or grounded on something? Is there weight?

When you were younger, what was your experience of grounding? Was your home and family grounded? What was your sense of place in the world? How did your needs and wants affect your sense of grounding? These personal questions will have different responses for everybody and affect the way in which we relate to others and self and our ability or inability to be grounded.

Exercises

1) Create art around your feeling of 'being grounded'. Create one piece of art that feels 'grounded' now create another piece of art that feels 'ungrounded'. What are the differences?

2) Look the word "ground" up in a dictionary. Try more than one dictionary. Research the term's etymological roots. Where did this word derive from? Is the dictionary term different from how it is used in conversation today? How has it changed?

3) Go out in nature and take a piece of string to make a circle on the 'ground'. Look closely at this small 'garden' and write a description of everything you see.

4) Reflect on the metaphor of 'ground' and write a poem.

5) Make a piece of art by starting with creating a background first.

Empathy

Reflective questions: Empathy is considered an essential quality in a good therapist. Empathy refers to 'being with', not a 'doing', nor a 'giving'. What types of metaphors does this evoke for you? What does empathetic witnessing feel like? How does it feel for the client?

Phrases like "Put yourself in the shoes of another" are used to express the importance of an empathetic response to others. It is easier said than done. How does one get a handle on what is empathy? It is different from sympathy, but how? What is being empathetic? What is being sympathetic? What are we trying to bring into presence? How do we know we are being empathetic? What are the dangers of sliding into sympathy in a therapeutic session? How do people show they are being authentically empathetic? What kind of attention would indicate a lack of empathy?

How could empathy be seen in the art? What metaphors could be manifested? Is there equality in the piece? What might be said in a narrative that would indicate empathy? Would it be seen in the art product? Could it be witnessed in the art making process? In a group session what could be observed to know there was empathy among group members? What happens to our body and our face when we feel empathy? How does that differ in look from sympathy?

One's first beginnings with empathy will come into play when receiving or offering empathy to others. What were your first experiences with empathy? Did you receive empathy? Did you give empathy? What might be the results of too much or too little empathy as a child? Who gave you empathy? Who did not? What circumstances usually grant empathetic attention in childhood?

Exercises

1) Create art to express your feelings, explore your ideas, and experience of 'empathy'.

2) Look up the word empathy in a dictionary. Try more than one dictionary. Research the term's etymological roots. Where did this word derive from? Is the dictionary term different from how it is used in conversation today? How has it changed?

3) Empathy training exercise (Siano, 2004): Work in pairs taking turns to be client and therapist. Have the person in the therapist role follow and copy the client's art making. Use the same material, colours and try for the same emotional tone. Reverse the roles and experience what it is like to be mirrored in the art making process. Describe observations and perceptions of following and mirroring in creating art. Describe what it was like to be followed and mirrored. Give feedback observing how it felt to be in the different roles and what you observed with the other person.

Containment

Reflective questions: In therapy we talk about the function of the therapist to provide containment. In art therapy we also refer to how the artwork can contain the emotions. But what does the metaphor of being contained mean? It can have both positive and negative connotations - some will feel it is positive with associations of holding, anchoring, focusing, and framing, while others may feel it is a term of limitation, boundaries and restrictions. Perhaps it is a combination of both, or perhaps it moves from one to the other depending on the context.

How do you experience containment? What is involved in offering containment in a therapeutic session? What containment means to you may be in constant flux in relation to what the client needs and wants. How would a therapeutic session be without any containment? What does it feel like to be uncontained? How does another feel contained? When might it be important to release what has been contained? How could this happen in the context of art therapy?

How might the metaphor of containment appear in the art? What can be seen as containers? Frames? Bowls? Rooms? Spaces? How would the feeling of being uncontained look in a picture? What would that feel like? What could happen without this aspect of therapeutic presence?

This part of presence is closely connected to early childhood development and the concept may relate to Winnicott's theory about holding and handling. What was the caregiver's style of parenting? Was the child well contained? Did the child feel safe when he/she was held? Were they over contained? Did they feel uncontained by unsafe handling? How did you experience containment? Reflect on your own history.

Exercises

1) Create art about your feelings, ideas and experience of 'being contained' and feeling "uncontained".

2) Create a carefully structured work of art and then spill or splash paint all over it. How does that feel? Now work the other way and start uncontained and then bring in structure to the image.

3) Look the word 'containment' up in a dictionary. Try more than one dictionary. Research the term's etymological roots. Where did this word derive from? Is the dictionary term different from how it is used in conversation today? How has it changed? Consider the differences when the concept is used as a verb, a noun, an adjective or adverb.

4) Examine the metaphor of containment in art to further expand your ideas: What is being contained? How does this container function? Does it hold something in? Is it keeping something out? Is the container empty? Full? Is it rigid? Flexible? Could it flood and spill over? Does it expand?

Mirroring

Reflective questions: The metaphor of a mirror is commonly used in the context of therapy. Mirrors provide reflection and an opportunity to see the self. When a child first discovers a mirror they think it is someone else – but slowly they realize that the mirror is reflecting his or her own face. This is an amazing discovery. We can also see our reflections in the eyes of another, in water, or in glass. When we look at ourselves in the mirror, what are we seeing? Is there more than just an accurate physical reflection? What does this mean for the therapist to provide or hold up a 'mirror' to a client?

When the noun 'mirror' is turned into the verb 'mirroring' in therapy the therapist is functioning to reflect the client. What does mirroring have to do with therapeutic presence? What would a session be like without mirroring? What is the opposite metaphor of a mirror? Blankness? Non-reflectivity? How do we communicate with mirroring? What is happening with our bodies? Our faces? Our eyes? How does one mirror verbally? What benefit is there to mirroring? What are the cautions around mirroring? How can you tell if you are mirroring effectively? What response are you looking for from the client? How do we use mirroring in our sessions? How does mirroring function for the client? How do you deal with your own reflection from the client? Should mirroring be different when dealing with different cultures?

How does mirroring manifest in the art? How might reflections be depicted in a work of art?

Do you have a sense or memory of your experience with mirroring as a child? What might it be like to be over mirrored? How would that be different from under mirroring? Were you mirrored appropriately? How were you seen? Were there times you felt more seen than others? How did your actions as a child motivate being seen or unseen?

Exercises

1) Create art to express your feelings, ideas, and experience of 'mirroring'.

2) Look up the noun 'mirror' and the verb 'mirroring' in a dictionary. Try more than one dictionary. Research the term's etymological roots. Where did this word derive from? Is the dictionary term different from how it is used in conversation today? How has it changed?

3) Create a self-portrait in art. Express how you feel from inside your body. Now use a mirror to create a self-portrait in art. Compare the 2 pieces of art.

4) Try to re-create a client's artwork. Try to 'mirror' the same physical and emotional expression. Write your reflections on the process.

Boundaries

Reflective questions: The metaphor of boundaries is commonly used in the context of therapy. In the context of therapy there are a number of boundaries, starting with the basic boundary of looking at the experience inside the session and outside the session. There is also the boundary of the professional relationship, which does not move into being a friendship despite the deep level of intimacy expressed. What are the possible personal and professional boundaries that a therapist may bring to a therapeutic session? How may cultural or social biases be involved? What boundaries are necessarily present in a therapeutic session? How does time and space in a session act as a boundary? Is the boundary of the actual space or room significant in a therapeutic setting?

What does a boundary refer to and mean? A boundary starts when a line joins or crosses itself and becomes a shape; immediately a boundary has been created. How does this translate into life? What are boundaries? Are they different in social settings? What about in professional settings? Around family or friends? Are there inappropriate boundaries? How do boundaries function in everyday life? Do they keep things in? Are they keeping things out? Are they there for protection? Can one have too many boundaries? Or, too few?

What signals are communicated or witnessed to recognize other's boundaries? What do healthy boundaries look like? What are unhealthy boundaries? What is good about having boundaries? How would authentic therapeutic presence be affected by the absence of boundaries?

How can boundary disturbances be seen in the art? How could it be seen in the art making process? What visual metaphors indicate a boundary: fences, frames, shapes, outlines, walls? How would a lack of boundaries be seen in the art?

How does a child's early boundaries affect him/her later in life? Are healthy boundaries relative to each individual? Winnicott developed the notion of children learning very early the difference between "me"

and "not me". How can we relate current boundary patterns with earlier patterns of the individual?

Exercises

1) Create art to express your feelings, ideas, and experience of 'boundaries'.

2) Use clay to make one piece of art by starting with a whole block and taking pieces of it. Then make a piece of art by adding pieces of clay.

3) Create artwork and then make a frame for it.

4) Several exercises could be relevant in the context of boundaries:

 a) The 3 triangles exercise

 b) Being in the World.

Chapter 7:

The Creative Process

> Creativity is any act, idea or product that changes an existing domain or transforms an existing domain into a new one. (Csikszentmihaly, 1997, p. 28)

Art Therapy is based on the belief that the creative process is healing and life enhancing. A fundamental premise is that developing creativity and fostering creative ability is integral to the development of a strong sense of self. Individuals will grow and develop a creative, strong sense of self in an atmosphere of unconditional acceptance and positive regard. A creative attitude to life allows one to approach the world in a positive and pro-active manner. The creative process is integral to our health – to finding new solutions to old problems.

The intention in Art Therapy is to rekindle the individual's healing or growth process. The focus is, generally speaking, to re-examine the areas of conflict or difficulty, to explore the relationship between the real and the imagined and to bring more consciousness and positive feelings to the artist/client. The art enables the therapist and the client to witness the client's position and process. With the use of art making in the creative process the therapeutic control of the process stays in the client's hands.

Csikszentmihaly (1996) writes about the importance of creativity:

> Creativity is so fascinating is that when we are involved in it, we feel that we are living more fully than during the rest of life. The excitement of the artist at the easel or the scientist in the lab comes close to the ideal fulfillment we all hope to get from life, and so rarely do. Perhaps only

sex, sports, music and religious ecstasy- even when these experiences remain fleeting and leave no trace - provide as profound a sense of being part of an entity greater than ourselves. But creativity also leaves an outcome that adds to the richness and complexity of the future. (p. 2)

Creativity is about perception and the expression and manifestation of it, being awake to all of one's sensory input. The word inspiration originally meant a breath of divinity or transfusion from the soul of the gods. Why are some people more inspired than others? In the ancient definition they were considered more deserving - but it is important to remember that to deserve they were prepared for the experience, which is something we can all practice.

You always have to choose what to paint and what not to paint, what colour to use, and what not to use. We include and exclude from our vision and our view. We can discover things by analogy or by anomaly - what is there, and what is not there.

Blocks to Creativity

Some of the enemies of creativity are: insecurity, fear of failure or criticism, laziness, conceit, tensions and hyper activity, lack of faith in oneself.

Inertia

Sometimes it is difficult to get started to begin to create – there may be a lack of energy or motivation. Energy may be being spent in conflicts, inhibitions or maintaining defenses. It requires effort and activity to move out of inertia and doing things like taking out old work to finish, or starting with a scribble or rhythmic drawing can help. The use of pre-art activities or free writing can help. Inertia – requires the physical act of creating and it is through doing and making that ideas and creativity will return to the individual. Simply thinking about what to do or make will not change anything.

Choice of a subject can be hard – making choices, learning how to make decisions. The urge to discard an unfinished picture should be addressed because the difficulties encountered will re-emerge in the next one and if you work it through in the present you will know what

to do next time. It is important to watch how you chose, and observe what motivates you.

Fear

Fear can affect the ability and urge to create. Some of the potential fears are: the fear of being seen or revealing negative aspects of self, fear of being inadequate in skill or expression.

Pride

Pride can function as an inhibitor in different ways: the individual may feel superior or inferior. He or she may have become conceited or grandiose from excessive praise and may have lost his or her balance. Pride related to inferiority may lead to constant dissatisfaction with accomplishments – there is a fixed ideal of perfection. It is important to emphasize that it is through practice and trial and error that the artist grows. Understanding the laws of growth as applied to creative art can help an individual explore issues of the ego in new ways:

Spontaneous Creativity

A general underlying premise of all the expressive art therapies is that there is a relationship of reversal between spontaneity and anxiety. Specifically speaking, to the extent you are anxious, you are not spontaneous; to the degree you are spontaneous, you are not anxious. Anxiety is a fundamental underlying issue in most individuals seeking therapy. In Art Therapy there is the opportunity to reverse these feelings by helping the individual develop spontaneity through a focus on the creative process.

Creative preparation

Creative preparation is a receptive state, a resting, and a taking in, a reflecting time. Creative work is an active state of giving out, releasing, expressing. The simplest form of rhythm is repetition, as when your breath expands and contracts. Breathe out to energize the cells; then breathe in to let your lungs fill with air.

Creativity includes a sensory process with an exploration of matter. Creativity requires a time of discovery; not to be interrupted, to allow concentration, to allow connection between the self and the universe. There is always a balance of opposites: near and far - to find a sense of space, dark and light - to build form, warm and cold colours - to

intensify the values, movement in and out of the picture - to create living form. Balance and understanding is required to create a large tree and a tiny leaf.

There are conditions more favourable to creative work:

- The external environment: space and light; materials ready with care and well arranged

- The internal conditions: a quiet repose, concentration, enjoyment or pleasure of the work.

The Creative Process as it pertains to Art Making in Therapy

There are a number of aspects intrinsic to the art making process of expression and objectification, which may be directly observed in the therapeutic interaction. These include:

Choices

There are concrete choices presented all the time: paper or clay, paint or pens, this colour or that colour, this brush or that brush, and so on. How do we make those choices? What do the choices signify? For some individuals the presentation of the opportunity of choice may be the first experience of having this power of choice in their lives. The individual has the opportunity to choose or not to choose, to do or not to do. Taking control of one's own creative process can be the first step towards a more general empowerment of the individual in his or her social circumstances.

Problem Solving

The opportunity to make choices and solve problems in the art making process itself is a basic premise of the art as therapy approach.

Expression/Translation/Transformation

Feelings, memories, fantasies or experiences, which are difficult to articulate verbally, can often be more easily and evocatively expressed in the art making process. They become subsequently transformed through the creative process of symbol formation. The opportunity to visualize the pain and see it as outside of one self facilitates the movement to translate the inner experience and articulate it in the therapeutic and interpretive dialogue. Art making is intrinsically more sensual and bodily oriented than ordinary speech and thus one may bypass the more obvious forms of speech censorship, which we all employ. A very real expression of rage will be transformed and can become symbolic as it is expressed in the art.

Transitional Object

Artistic expression can serve as a transitional stage to further development. The development of the transitional object and the

ability to symbolize or make substitution for the real thing is basic to a child's stages of development.

Impulses

Also in the art, various impulses kept out of awareness appear and want to be dealt with. Aggression is a predominant affect, which is often repressed and which finds a safe release in the creative process.

Inner Conflicts

Bringing to light specific issues can be like finding a sunken treasure. The therapist is in a position to facilitate this process of recovery and help the individual understand how symptoms or personality traits are derived from attempts to cope with external stresses and internal conflicts.

Access to the Unconscious

The art provides an opportunity for accessing the unconscious and concretely visualizing the inner conflicts. Through the artwork and the verbal associations one finds evidence of the unconscious and the roots of the present emotional state. The art approach to therapy tends to bring unconscious memories into consciousness and this can enable one to fill in the emotional gaps in one's life. In art there is more direct access to unconscious and metaphor; images and repressed feelings have a tendency to emerge despite our best attempts to defend against them.

A man training to become an addictions counselor tried several times during an art therapy workshop to elude his own personal material. His first picture was an escape fantasy of sailing away in a boat. On the shore there was a cabin with a blackened window upstairs. In dialogue as we looked at the art he realized that he had depicted the cabin where he had witnessed his sister's abuse as a child. The next day he thought he would just make a clay candleholder because he did not want to explore intense personal feelings. During the closing circle, he suddenly brought forth his clay work. The candleholder had the word "insight" inscribed. He said that he had realized that it meant that he wanted to hold a candle up, to light up all the dark places where abuse has occurred and bring insight to himself and others. It was a very powerful moment when he saw how he had moved through the week from wanting to escape to wanting to see and understand.

Special note: The essentially metaphoric nature of the art therapy approach in treatment is one of the most significant therapeutic aspects that makes art therapy such a natural and familiar process in healing for native people. The native culture, language and spirituality are so eloquent in the concrete and natural use of metaphor that applying it to art in therapy can be very profound.

Spontaneous Art Therapy & Directive Art Therapy

The spontaneous or non-directive art therapy approach is an empowering process for the client and is a client-centered approach. The client chooses what to create, what materials to use, what issues to address in session. The art therapist, who uses a spontaneous approach, holds the view that the unconscious is at work in the creative process and that the issues will be revealed regardless of what is created or not created. A blank piece of paper may be very significant and eloquent in its silence. This approach views any part of the process or product created in the art therapy session as a springboard for the therapeutic dialogue. It requires more from the therapist in terms of spontaneity, trust and belief in the art therapy process and belief in the essential healing work as being the responsibility of the client.

In a directive approach the therapist assumes more control and structures the session by suggesting a topic or issue to be expressed in the art. Suggestions could be: draw your family, draw your favourite fairy tale, or draw something you are angry about. This last direction was part of a planned activity in a boy's social skills and self esteem group that I co-facilitated shortly after graduation. This was one of the first times I had witnessed a directive activity as my own art therapy training had focused on the spontaneous approach. Well - we got angry pictures all right! We also got five disclosures of sexual abuse in a group of six, and tremendous emotional reactions. This approach clearly can be very effective but a support system must be in place. With this example it is interesting to note that the counselors at this agency had been using these kinds of directives prior to my involvement but they had viewed the art as a cathartic release of emotion. However, with an art therapist looking at the images and listening to the boys' descriptions, there came a much deeper understanding of their experiences and inner dynamics, thus the disclosures.

There are different precautions that one must be aware of in using this kind of approach. Because one has taken control in the session then one is also responsible for closing down or resolving issues with the client by the end of the session. With children one needs to be careful and limit certain art materials as they can become over stimulating, for example clay or the use of lots of water with the clay.

A client-centered approach allows the client to set the tempo for therapy. Therefore, if the client is in charge of the choice of art, they are more likely to only go as far or as deep as they feel ready. There is also what one might call a client-centered open-ended directive approach in which open-ended suggestions or possibilities of issues to explore emerge directly out of dialogue with the client. For example if you are talking about a particular issue you could suggest that they might want to try and express it in the art. The open-ended manner also leaves them the choice of whether to explore the suggestion or not. Another ground rule for beginning art therapists is to not introduce any activity until you have experienced it for yourself and found it to be integrative and of personal value.

Spontaneous expression is generally emotionally safer for an individual as they can stay in charge of their choices and therapeutic process. Some individuals, however, feel safer with a few directions, which can be presented in an open-ended fashion where right or wrong responses would not apply. The directed approach may be easier or necessary for the clinician as there can be value in focusing attention in particular area, or they may be operating under a short-term therapy mandate. It just simply may be more pragmatic to be directive. This can occur during either individual or group work where the therapist feels constrained to actively encourage the client to move quickly into key issues. However it is not documented that a directive approach is any quicker in terms of treatment so it may have more to do with a therapist's level of comfort in a specific treatment plan and approach.

Only one time in my art therapy practice have I been firm in giving a directive and on this occasion I only said that it was important for the client to make a mark on the paper. I had been working with a young mother for an extended period of time doing verbal therapy and counseling her regarding her two small children who had been abused (and whom I was seeing in art and play therapy). She was having difficulty in taking action to protect her children and to be assertive in making choices and decisions in her life. It appeared that perhaps this was being reflected in her reluctance also to use the art. I placed the directive in the context of her practicing taking action with all the risks involved. She managed to paint a small black area on a corner of the page while turned the other way so that she couldn't see what she was

doing. This piece of art was a turning point in her therapy. She began to paint very evocative pictures and develop her sense of self worth and empowerment as she took more charge in the art making and in her parenting.

The therapist's role is to provide a safe and supportive environment for self-exploration. This includes the ability to accept, or tolerate all of the individual's repressed feelings and traumas. This allows the individual to come to accept all the divergent aspects of him or herself and find meaning through creative self-expression. The ingredients of the supportive environment are defined by specific boundaries of time, of place, and of the therapeutic relationship.

Some activities and techniques are useful for art therapy groups with children or adolescents. It can be beneficial to introduce something like puppet making or styrofoam print making to extend their creative ideas and enhance their sense of self-mastery and self esteem. Generally speaking, in a spontaneous art therapy group, the spectrum of choice of art materials would always be available. This means that a child could paint or use clay at any time if they choose, but they would be exposed to other possibilities. This would provide opportunities for coping with new information, practicing problem-solving skills and working through technical frustrations.

The ground rule is that there is no wrong way to create art. The only parameters the art therapist needs to set would pertain to safety of the individual, group members, the therapist and the environment. It is not beneficial to allow a child or adolescent to destroy the art therapy room as this would lead them to believe that their anger is dangerous. It is important for the art therapist to create an indestructible holding environment and to not be destroyed by the artist/client's actions. Anger and aggression need to be focused, symbolized, expressed and released through the art making. Sometimes the therapist needs to set other parameters regarding the use of material due to budget constraints. For example, the issue of whether to allow pouring paint may come up. Pouring paint may be important for a heavily defended repressed individual but problematic for a child who needs containment. It is always preferable to set your table and environment in a way that does not lead to extensive setting of limits. For example, you might have

the paint jars half full so that it both doesn't encourage pouring and if pouring occurs there is a limit to the amount of paint consumed.

Regarding the release of aggressive emotions there is a basic guideline that I use regarding pounding clay. Artist/clients are not given the opportunity to pound clay with implements as this can easily escalate their aggressive feelings rather than help them to give symbolic form to the issue at hand. They can, however, pound the clay with their fist and can have enough clay so that they don't hurt their hand. The distinction here is that in using their own hand they will get physical feedback from the expression of the aggression. This parallels the client's outside life in that he or she will get feedback or consequences from the expression of aggression. The intent is to provide cathartic release, and to encourage symbolic expression and verbal articulation regarding the roots of the anger. It is hoped that this will lead to insight and the development of skills in the management of anger.

I want to emphasize the importance I place on spontaneous art therapy, looking at the art and reviewing it in any of the ways already indicated: free association, looking at the focal points, amplification, and gestalt or with the phenomenological method. One can use whatever has been created as a springboard for the process.

It is my belief that directives should emerge directly out of the context of the client's process. However, there are some directives that encourage self- reflection and there are other techniques or activities that will motivate certain clients or groups. Therefore I believe that it is good to be familiar with a number of different possible directives and activities that might be appropriate or adapted at any point. I don't want to leave the reader with the impression that I use primarily a directive approach because of all of the activities included in this book.

Chapter 8:

Spontaneous Art Therapy & Postmodern Techniques

Spontaneous Art Therapy

Directive: Create whatever you like. Express how it feels to be you. Enter into a responsive dialogue with your image. As art therapists we must learn to value the image in its own right. It is not necessary to have dialogue. Dialogue can come later or with some clients, or it may not come at all.

Recommended Population: All ages.

Intention:

- To know one's self

- To integrate uncovered aspects of self

- To play

- To relax and release

- To give expression to feelings

Materials and Method: Give a free choice of materials to choose from. There is no right or wrong way to be spontaneous.

Exploration:

- Expressed metaphors

 o of suppressed unconscious material

- o of hopes and fears, dreams and wishes

- o of self expressed symbolically

- Approach using a psychoanalytic method of free association

- Approach using the phenomenological method and 'What do you see?'

- Approach using a person centered or gestalt approach

- Keep a journal about the art. Write a description of the artwork.

- Write associations and poetry.

Therapeutic Precautions:

- Likely to introduce all key issues.

- Take the time to explore, express, honour, and contain the feelings.

Alternatives:

- Edith Kramer: put out only red, yellow, blue, black, and white paint to encourage spontaneous mixing of paints and colours

Some techniques to encourage spontaneous art making:

Judith Siano introduced the Haifa model of phenomenological Art Therapy at the Kutenai Art Therapy Institute in July 2004. She would put out a palette of colours – always the same colours and in the same order on a mixing plate that would encourage mixing of colours. Judith also had a wide variety of paper with different sizes and shapes to chose from (circles, ovals, squares, rectangles – both large and small). These were attached to the wall to encourage individuals standing up to create. Her directive was to create a number of different images and to

try different shapes – both ones that you are attracted to and ones that you are not comfortable with.

Some other techniques introduced were to place the image on to bigger paper to extend the possibilities of where an image could develop. This is similar to Edith Kramer's (2000, p. 47-69) ideas of the "Third Hand" of the art therapist. Also images could be cut up and reworked.

Spontaneous art can also include the introduction of a variety of art making techniques like Michael Haslam's list of modern art methods. Some of the Modern art techniques were outlined and humorously expanded by Michael Haslam and students at a KATI workshop in 2004.

Collage: non-representational cut and paste

Frottage: rubbing with graphite sticks on grainy paper to bring up the image of the surface that is being drawn on.

Grattage: scratching freshly painted surfaces with a fork or other sharp object.

Decalomania: crushing paints and chalks between two panels

Splattage: acts of physical energy (violence) with paint and brush

Dansage: using large body gestures

Montage: mono-prints using objects and materials

Rippagio: tearing up paper and gluing it with paint

Isolation: drawing outlines around identified abstract shapes

Foldatio: printing folding parts of canvas or paper in on itself

Some art making approaches that could be considered postmodern are:

Different forms of collage and construction using:

Appropriation: using appropriated images and using print material with these images. This might be from the internet or magazine images.

Juxtaposition: substitution of random images for personally generated abstract marks.

Hybridity: incorporating various media together as well as the cultural blending of many works of art.

Interaction of text and image: incorporating images and text in art.

Layering: layered imagery can evoke the complexity of the unconscious and conscious mind.

Representation: This could include the strategy of locating one's artistic voice within one's own history and cultural origin.

Gazing: the traditional meaning of an image is challenged when it is presented with a more stereotypical depiction of a similar image. A shift occurs in the context in which a familiar advertisement is seen. This is a means of controlling perceptions of what is real and natural.

Re-contextualization: positioning a familiar image in relationship to pictures objects or texts with which it is not usually associated.

Eclecticism: the deliberate removal of elements from their original context and arbitrarily bringing them together.

Collage

Collage developed into a significant art form in the mid 1950's and included assemblage, combines, and happenings. Its antecedents were dada and surrealism. At first there was a focus on the symbolic use of images rather than the concrete nature of the art materials. There was an attempt to undermine the aesthetics of painting by using the actual material – wallpaper, or wood grain – as Picasso and Braque did. Collage is defined by McCreight (1996) as "An artistic composition of material and objects pasted over a surface, often with unifying lines and colour." The word comes from the French 'coller' meaning to paste.

Originally, collage developed out of the use of found objects and the desire to include the "real" in a piece of art. Formerly, a piece of art was always a depiction of the real through creating illusion in perspective and drawing and painting techniques. With the emergence of photographs, which captured a moment of "real" time, painting was freed to include and explore the expression of feeling and a more intuitive response to the subject matter.

The sensation of physically operating on the world is very strong in the medium of papier colle or collage, in which various kinds of paper are pasted to the canvas. One cuts and chooses; and shifts and pastes; sometimes tears off and begins again. In any case, shaping and arranging such a relational structure obliterates the need, and often the awareness, of representation. Without reference to likenesses, it possesses feeling because all the decisions in regards to it are ultimately made on the ground of feelings.

Artists such as Robert Motherwell used his own objects and memorabilia in his collages so that they became more autobiographical than his paintings. Others like Kurt Schwitters focused on including what he referred to as 'waste of the world' into his art.

Collage provides an opportunity to explore issues of gender, values and social consciousness. It is important to have a variety of magazine images from different sources and different cultures, not just National Geographic and Cosmopolitan. It is also a good idea to have cut out images and words to choose from so that the art making time is not taken up with leafing through magazines and getting distracted by the content. Images can be cut up, mixed, juxtaposed, added to and drawn on. Words and phrases can be included to make visual poems,

jokes or social or political commentary. The exploration of roles and values emerge easily through the discussion and alteration of media images and public figures. The use of collage with the techniques of cutting and gluing provides a concrete metaphor for the possibility of deconstructing and reconstructing concepts of self and other. It can be used to explore past experiences and themes or future wishes and dreams.

Collage can be expanded to found objects and the building of constructions. It can also include the creation of collages on boxes, which could take the form of memory boxes or inside/outside boxes. Variations of the inside/outside theme have been introduced by many art therapists and applied to boxes, full body portraits and masks. The underlying suggestion is that the individual depict, express or put on the inside how they feel on the inside and put on the outside how they present to the world or how they feel the world sees them.

Collage can be done with a variety of different kinds of coloured and textured paper to create unique effects. Photographs and personal mementos might be included.

The use of torn paper and the cut or tearing up of the individual's own art can be a metaphor for the recreation or reevaluation of self and other.

Another directive might be to create a collage of the environment you live in. Create an image that holds the mood –it could be hot, cold, stormy, peaceful etc. (Riley, 1998)

It is important with collage to consider the kinds of available imagery. Is it appropriate or over stimulating? Collage can be both liberating and it can re-enforce a defensive pattern with safe and pre-cut images.

Collages

Directive: There are a number of ways to approach making collages.

- Create artwork with "found" images or fabrics.

- Poems can be made in collage from taking words, phrases and letters from magazines and making your own meaning. They can also be combined with images.

- Collages can be built from coloured shapes to be more like a mosaic image.

- Found objects like boxes can be collaged.

- Make collages of animals, drawing word balloons for what they might say or think. Some may want to depict their family as animals in this way.

Recommended Population: Children, adolescents, adults.

Intention:

- To stimulate creativity

- To build visual vocabulary

- To free associate through "found" images

- To reduce anxiety about art making ability

- To have an opportunity to discover significance in common images

- To enhance perception

- To reflect on social and cultural image

Materials and Method:

Have available fabrics, cut out words, cut up segments of images, and full-page images, as well as magazines for them to discover their own.

- Magazines

- Scissors

- Glue

- Paper

- Optional objects to collage onto

Metaphor:

- Cut & paste = choices & reconstruction of self

- To reflect on social construction of self

- To provide an opportunity for objective reflection

- To legitimize: sense of commonality with images

- To build commonality and to bracket out isolation

- To see self in relation to social contexts

- To make choices and to attach

- To make connections & constructions

- To be part of and in relationship to the world

Inside Outside Box

This morning I read in a book about fairy tales, a definition given by a 5yr old girl regarding mythology. She said when asked what myths were "Those are stories that aren't true on the outside. But they are true on the inside!" (Mueller-Nelson, 1991, p. 2)

Directive: You may take a box or several boxes or create a container. On the inside of the box put images that express and reflect how you feel on the inside. These may be attached to the sides of the container or they may be removable. They may be images, words, photographs, or cloth. On the outside of the container put images that express either how you feel on the outside of yourself, or how you present yourself to the world, or how you interact in the outside world.

There are many ways to make boxes or baskets; for example they can be circular, triangular, rectangular or square. I have even had a student make a very tall hat, sort of like a top hat or the hat of the mad hatter in *Alice in Wonderland*. You may use collage, construction, sewing, paint, clay or drawing. Be as creative as you like. This is to be a symbolic representation of how you feel today; tomorrow you might make a different box. There is no right or wrong way to do this activity. Be gentle with yourself and allow your perception of your inner and outer selves to emerge.

Recommended Population: teens, adults and art therapy students.

Intention:

- To focus the individual on the relationship and distinction between the inner self and the outer presentation of self

Materials and Method:

- Magazines

- Scissors, white glue and glue gun

- Fabrics, needle and thread

- Paints and brushes

- Boxes

- White and coloured paper

- Construction materials

Metaphor:

- Pertains to self and consciousness as a physical space

- Focus on how we see ourselves and present ourselves to the world

When an art therapy directive is given that involves so much conscious self-reflection in the creative process, the dialogue tends to start in the self-reflective mode. I am referring here to the three levels of questioning: the concrete, metaphorical, and self-reflective (discussed in Chapter 5). In this dialogue the artist/client will generally start with the self-reflective and speak about all the things that they thought of and the decisions they made about what images to include and what to exclude and how and where they should be placed. It may be important for the therapist to ask about more of the concrete and metaphoric components.

Several aspects to focus on in the dialogue:

- To ask about the process and if there were any surprises or insights;

- To listen to the whole narrative and to reflect back the essence;

- To check out whether one has understood what was being communicated;

- To listen to the metaphors and explore further associations;

- To maintain a focus on the art, bringing the dialogue back to the art and connecting it to the concrete image / construction;

- To explore the artwork and remember not to make interpretive statements or assumptions;

- Questions are to be open ended to enable the artist client an opportunity for personal self-reflection and to be able to discover the significance for themselves.

Exploration: *(suggested starting points – the artwork may elicit others)*

- How does it open or close?

- What is the size and shape of the box?

- Are the feelings inside the box the painful ones? Or the positive ones?

- What is the perception of self in the world?

- What is the relationship and congruence or incongruence between the inside and the outside?

- What has been included and what is left out?

- What are the metaphors used?

- What are the strengths?

- How did they use creativity and imagination?

Therapeutic Precautions:

- Accept and respect the art as it has been made and presented.

- It is important to allow enough time to make art. This process involves a great deal of self-reflection and to be rushed or to have to complete prematurely does not facilitate a process of integration.

Alternative Ideas for Collage boxes

Nick Zwaagstra presented the idea of creating a memory box at the CATA conference in 2004, as an activity that provided a form for grief work. It facilitates a way for the child to maintain a connection to the deceased.

Collage Emblems

Ruby Truly, actor and videographer, introduced this activity at KATI, 2002. It has been adapted from theatre to art therapy.

Directive: This activity usually starts with some breath work and warm up drama exercises to enhance physical and perceptual awareness before starting the emblem work.

- Quickly rip out 3 pages chosen from a stack of magazines

- Out of these three pages spend time ripping pieces from these pages and combining them in a way that appeals to you (Be sure to check on the back of your pages)

- Examine your collage and consider movements and sounds in response to the feel of your "emblem"

- Dramatize in front of group or therapist using voice and/or movement

- This can be a full day activity whereby, after choosing three images and working with them, you add two more, and later two more, to a total of seven images that would be expressed dramatically in the group.

Recommended Population: Adults, Adolescents

Intention:

- To self reflect

- To explore a random decision making process & free associations

- To explore the personal metaphors and significance of intentional and/or unintentional choices.

Materials and Method:

- Magazines & tape - spread out magazines in the middle of the floor

- Large space for drama

- Be sure to help the group keep moving through the various parts of the activity in a timely manner

Exploration:

- How was the process?

- Can you speak about the images chosen? Any insights or associations?

- What was it like to expand a visual image into a drama?

- Aggressive/ passive; loose or tight movements

- Voice tones, concentration, focus, pleasure & unpleasure

Therapeutic Precautions:

- Some people will not be comfortable with the dramatizing aspect.

- Allow for a range of responses.

Useable Objects:

Painting useable objects with acrylic, latex or metal paint. Some ideas that have been done are:

1) Hard hats: introduced by Nancy Lee Smith at Art Farm in Winlaw.

2) Chairs (wooden) that can be used in the studio and then taken home after the program. Duanita Crofton found this to be successful working with street youth in Victoria.

3) Wooden furniture painted with images depicting how you feel on the inside and life on the outside. This project done at a studio in New Orleans with young drug addicts. The furniture was being sold and the money split between providing more paint and furniture and the artists themselves as well as going into a fund to create school bursaries for the youth/artists.

4) Windows and doors have been used by KATI students with adolescent groups. A mural project was done with 4 doors hinged together as a free standing unit and painted on both sides. Windows with wooden frames were painted with acrylic paint.

Treasure Maps

Julia Cameron (1996) introduced the idea of making a treasure map for self-exploration. This version has been adapted to art therapy and was introduced by Duanita Crofton at a KATI workshop.

Directive: The therapist explains to the group that the intention of the activity is to have participants focus on their goals for their lives- what they wish for, want, desire, need, and aspire to. The therapist reminds the group that most of us may wish for material things, such as a car or a nice house, but that each of us also has wishes for things in non material domains: relationship, career, recreational, athletic, emotional, spiritual, academic, etc., and that in this activity we want to reflect on all our wishes. The idea is to create a treasure map for one's own life. The map should include the steps and path to get to where you want to go.

Recommended Population: Children, adolescents, adults. It can be a good choice for an activity in adult groups during the last few sessions.

Intention:
Participants make maps of what they would like to do, achieve, or experience in their lives. It can be done with a combination of drawing, collage and words if desired.

Materials and Method:
- Paper
- Crayons, pastels, markers, chalks
- Paints & brushes
- Magazines, scissors, glue- it is better to have lots of pre-cut images

Metaphor:
- Treasures can be viewed as wishes, desires, needs, people, places, or activities. What do they mean for you?

- What does your treasure map tell us about what you want?

- Does each picture represent a want or a need? (Discuss difference)

- Which are your most important wishes?

- What will happen if you get your wish? What will happen if you do not?

- How realistic are your wishes?

- How will you make your wish come true?

Therapeutic Precautions:

- Some individuals may feel at a loss because they don't know what their goals are. It is best to introduce this activity when it naturally emerges out of the client's present concerns and the individual has some ego strength.

Chapter 9:

Opening and Closing Activities

Opening Activities

Directive: Write your name on a large piece of paper and illustrate or decorate it.

Recommended Population: Everyone in a new group situation.

Intention:

- To build relationships and introduce group members

- To establish safety and trust and a level of comfort

- To facilitate self expression and stimulate sensory awareness

- To emphasize freedom in group therapy with a 'safe' starting activity

Metaphor:

- First impressions of: space, client, therapist, group

- Opening, a book, a door, etc.,

Therapeutic Precautions:

It is important to accept and honour all art and verbal communications. There is no wrong way to present oneself. As a therapist it is important to work starting where the client is.

Alternative Ideas:

Tell a story about your name and/ or nickname. Think about the stories told about your name, who are you named after, and the meaning.

Create individual mandalas around a large sheet of paper placed on the table and then draw connecting lines and fill in the spaces.

Draw yourself as an animal. Speak about the qualities you like about this animal.

"Telephone" or "Password"

Directive: This is not an art therapy activity, but it can be used to illustrate the importance of confidentiality in an art therapy group. This is a group activity where one group member whispers into the person's ear beside them a sentence. Then that person passes it on until it goes around the circle and the last person says it out loud.

Recommended Population: Groups of children and young teens

Intention:

- To illustrate the importance of confidentiality

- To demonstrate the problems of distortion when a discussion is taken out of context and passes into the zone of gossip

- To focus on the importance of listening and the difficulty of accurate listening

- To realize the significance of first person contact

- To recognize the importance of being understood.

Materials and Method:

The sentence is passed around via whispering in the ear of the person beside you. The last person in the circle says the sentence out loud and it is compared with the starting statement. Try the same exercise and go the other way around the group. Allow a different individual to start the telephone game. Have the therapist start the game with a positive or funny statement.

Metaphor:

If it goes around accurately then it is an opportunity to compliment the group on their exceptional listening skills. If it is distorted then one can speak to the problems of distortion when information is passed from one to another.

Therapeutic Precautions:

It is not advised for groups where someone may have a speech impediment, or for groups with intimacy problems in regards to whispering in someone's ear. Someone may make a rude or derogatory comment that others feel uncomfortable passing on.

Animal, Plant and Machine or Tool

Directive: This activity can be done after an opening circle when each group member has introduced themselves and perhaps told a story about his or her name. This is a symbolic group feedback exercise in which each group member draws the name of another group member and the task is "to portray the person whose name they have drawn as some kind of plant, animal and machine" (Moon, 1992, p. 83).

All of the images are put up on the display boards and group members may wonder which images represent themselves. There can be some very interesting dialogue regarding perceptions and symbolic choices. It does need to be made clear that it is another's perception of you and not necessarily how you see yourself. This is a very interesting exercise for the beginning of a school year with training art therapists. Doing an activity like this after an opening circle can facilitate students getting connected and leads naturally into a discussion on interpretation and symbolic representation on the importance of listening and the dangers of making assumptions.

Exploration:

- Have all the art up and let anyone identify if they feel that certain images are about them. If so the explore the associations to the symbols.

- Let the artist describe the qualities they noticed that lead to the choice of symbols.

- Let the group offer up who they think it might be.

Carousel

Although Sadie Dreiker (1994) writes about carousel in her book *Cows can be Purple,* this activity has been used and adapted by many people in many different variations.

Directive: When I introduce this activity I like to say something at the beginning like, "We are all going to work on these pieces of art together. You will get to start and finish one piece, but everyone else will contribute. As we go around the table, when I say 'change' you will move to the next piece and look at what needs to be added".

Recommended Population: It can be introduced to groups of any age and it is a good team building activity. However, I would caution using it with children who might be attached to the images they make and upset by others "ruining" them. Disabled or elderly individuals might require the paper being passed to them instead of moving around the table.

Intention:

- To encourage creativity and playfulness

- To act as a dis-inhibitor by allowing individuals to participate in making art without worrying about the end product

- To reduce anxiety about art making

- To strengthen group connections

- To encourage creativity

Materials and Method:

- Paper, paints and brushes, pastels, markers, chalks

Set up the table with a sheet of paper for each group member. It can be any number from six to twelve. Place paints, brushes and drawing materials in the middle like a banquet. As this is a fast moving activity, it is great to have many sets of materials around the table so

everyone can choose quickly what they will use for each different piece of paper.

Everyone is going to wait and start painting or drawing at the same time. They paint for a minute or so, and then the facilitator says, 'change' and they move one place around the table, similar to the Mad Hatter's Tea Party. This goes on until everyone is back to where they started. I like to give people a minute or so to finish anything they like on the piece they started. It is like having a conversation where you have an opportunity to respond. Then put all of the images up and look at the art together. Possible question: "Are there stories or images that you like or don't like?"

Exploration:

- It can be a great exercise to emphasis the importance of the individual's own interpretation of their art because images or marks may be easily misunderstood.

- Generally, in a shared activity of this nature the individual's personal boundaries are not so rigid.

Metaphor:

- Creating a family or party together

- Inclusiveness - everyone contributes together

- We are all parts of a whole

- "How did you feel adding to another's work?"

Therapeutic Precautions:

Strong feelings about boundaries may emerge. It is important to discuss in the beginning about how people feel about having other's drawing on their work. Sometimes it is beneficial to decide in the beginning whether or not this will be allowed.

Alternatives:

a) Try with different materials and sizes of paper

b) Vary lengths of time depending on group dynamics

c) Have a theme at the beginning: making a garden or creating clowns

d) Fold up people or creatures

Personal picture frames and Carousel Animals: A Group Activity

This is a large mural project introduced by Judith Siano (July, 2004) at a KATI workshop. Monica Carpendale facilitated a variation at the CATA conference in Oct. 2004 as a tribute to Shirley Riley and other mentors.

Directive:

- Judith Siano (2004) introduced a variation of carousel using paper folded into 3 sections of varying sizes – biggest at the bottom where participants draw/paint legs of any kind of creature, animal or person. It can be real, fantasy or science fiction. Don't paint the background. Then participants look around and move to another page with legs that they are attracted to and paint/draw the torso. Then after looking around, they move to another sheet of paper and paint/draw a head. Later the figures are cut out and placed on to a mural sheet as if in a group portrait. The mural also has a series of steps to be created.

 o Hint: Start with the legs because that is where there will be the least anxiety and self-criticism. Then the next part becomes a response to what has already been created. It is a metaphor for social construction.

- Start with a large piece of black paper from a roll of building paper. Put it up on the wall (preferably) or it can be done on tables or the floor.

- Hand out small pieces of paper (squares 4" x 4" approximately) and have participants draw an image spontaneously with oil pastels. Then have the participants choose a piece of coloured construction paper as a "frame" on which to place the first drawing.

Ask the participants to write associations to the image on the coloured paper.

- Next have the participants take turns sharing the image and speaking the words and associations and placing the coloured paper and image on the black paper with tacks. Ask everyone to look at the whole placement on the black paper before the next person chooses to place the image and share associations. When everyone has placed his or her image, each person chooses an oil or chalk pastel to make a frame around the paper image.

- Then ask the person on the outside edge draw a line of connection to the image on the far opposite edge. This line of connection is from the frame to the frame and is not to cross over other images or frames. Then have everyone draw lines of connections to each other's frames. Don't cross over frames - just attach to them.

- Next have all the participants choose another colour to fill in the spaces between the lines without covering up the lines. Depending on the number of participants you might suggest that if everyone fills in at least five spaces it will soon be all filled up.

- Later, either in the same day workshop or at the end of the week, the images and associations are removed and then fold up carousel creatures are placed in the positions of the images like a group portrait and photographed. Group members can also take the position they had placed the creature in, and copy it for the group photograph.

This activity is a good way for participants or students to get to know each other at the beginning of a school year or at the beginning of a workshop. It provides an opportunity for personal expression within the group context and it also emphasizes the importance of respecting boundaries. Be aware that participants may have concerns regarding personal boundaries and respect. They may have difficulties

regarding connections and intimacy and where to situate themselves in the group. The silliness of placing the fold up animals in a group portrait functions quickly to reduce anxiety and increase permission for playfulness.

Anger thermometers

Directive: Have individuals draw a thermometer and write in the words that mean for them how anger can get hotter and hotter. Have them show where they are right now on the thermometer. This is not an art therapy activity; however it can be useful as a springboard into discussion about issues of anger.

Recommended Population: children and young teens

Intention:

- To explore different ideas and concepts regarding anger

- To release anger

- To develop self awareness about the development of anger

Materials and Method:

- Pastels & markers with paper

Metaphor:

- To determine the progression of anger and the idea that anger can rise and get hotter, but it can also subside and go down

- Metaphor of anger as a fever

Exploration:

- What words do you use when you are angry?

- How do you look when…?

- What helps to cool your anger down?

- Size, intensity, language use

- What starts the anger up?

- How, and why does it intensify?

Therapeutic Precautions:

Be prepared as it may escalate or solicit painful or aggressive disclosures.

Alternatives:

Cartoons: Drawing instant replay cartoons to illustrate how the anger gets started. Introduce the use of spoken word and thought balloons.

Anger volcano: Make a clay volcano and put in baking soda and then pour in vinegar and red paint. It will bubble over. Talk about releasing anger. Use a tray or pie plate to provide a base and container for the metaphoric flow of anger.

I packed my bag to Paris or Timbuktu....

Directive: I packed my bag to Timbuktu and in it I put _____
(things that make me angry). Variation on "I packed my bags to Paris".

This is a group activity that might be used in an opening circle. Each member of the group will say what makes them angry, but first they must say what each person before them said sequentially in the circle, and then add theirs at the end.

Recommended Population: groups, children, preteens, and young adolescents

Intention:

- To release angry feelings

- To develop listening skills

- To remember what others have said

- Get support for expressing anger appropriately

Materials and Method:

A group gathers in a circle. One person starts by saying the opening phrase and adding what makes them angry. The second person says what the first person says and adds their cause of anger. This pattern continues around the group until the bag is full. At this point the group needs to decide if they will take the bag to Timbuktu or dispose of it differently. You can go several times around the group if people are able to remember what has been put in the bag. Disposal of the bag is very important.

Metaphor:

- To have your concerns heard, witnessed, repeated and reflected back.

- To provide group support - group discussion regarding the disposal of the bag is important.

- To give permission to give expression to pet peeves or major issues.

- To release angry feelings.

- To provide support and humour.

Therapeutic Precautions:

It is important to not allow just names, but rather to focus on the behaviour that makes one angry. For example, not just putting Sally or Tom in the bag, but focus on naming the behaviours "When Sally pinches me ...", or "When Tom won't play with me ...".

Alternatives:

- Choose other topics to focus on – for example – put your strengths in the bag.

- As a name game – one could add something that you like to do.

Closing Activities

Symbolic Gifts

Directive: Each group member draws, in a carousel, a symbolic "gift", for the person named on the separate pieces of paper they have received.

Recommended Population: Groups.

Intention:

- To gain a sense of closure and summation

- To emphasize strengths

- To promote object constancy

Metaphor:

- To say goodbye and give a symbolic gift

- To honour group members and to leave graciously.

Therapeutic Precautions:

Some clients may have strong feelings towards the therapist around closing. Some may be very negative and some positive.

Heart Cards: Cut out large hearts and decorate them with the name of each person in felts or coloured glitter using glue to write with. Pass around hearts and each group member writes something positive.

Fortune cookies: Take a bag of fortune cookies and write new fortunes to insert.

Thank you poems: Write a list poem where every line starts with thank you for ...

Art Review

An art review can be used in closing or, periodically, to review the art therapy process. This is a unique aspect of art therapy as there is a visual record of work done through the process. Taking the time to put up the art and look at all the work can be an integrative part of the therapeutic process. The essential feature of art reviews is to look through all of the client's, or student's artwork. It can be looked at individually, or hung up like an art show. There are many ways to do this but it is very important to experience and witness the multitude of ways to do an art review. It is an integral part of the therapeutic relationship between the client, the art and the therapist.

Explorations (some ideas)

- To look at the art chronologically and discuss the essence and associated insights;

- To look at images that one likes or doesn't like;

- To consider the use of colour and see how it changes through the artwork;

- To consider the styles used and the evolution through the process;

- To discuss artwork that perhaps hadn't been debriefed;

- To consider the key symbols and the relationship between images.

Chapter 10:

Pre - Art Activities

Finger Painting

Directive: Set up the finger paint paper by taping it down or placing it in a tray. Place spoonfuls of finger-paint on a piece of cardboard or plastic lid beside the paper.

You can also use a second sheet of paper and place it over the finger painted image and take a print by gently pulling it off. Images can be framed and titled. Roll up your sleeves and go to it!

Recommended Population: Children, adolescents and adults: who need to learn or practice playing, making a mess, and getting their hands into materials.

Intention:

- To release tension

- To emphasize freedoms in therapy

- To eliminate anxiety about art materials and process

- To show the support value of expression and process rather than "fine art"

Materials and Method:

- Finger paint

- Finger paint paper or tin foil works well

- Aprons or paint shirts!!

Metaphor:

- Direct expression (hand to paint: no distancing)

- Permission to release

- Expression of feeling

- Simplicity of unconscious expression

Exploration:

- How did the process feel?

- What do you see in your image?

- Explore body movements & see the movement of your fingers in the paint.

- Recognition of page boundaries.

Therapeutic Precautions:

- Possibility that it might be too regressive for some

- Possibility of too much chaotic discharge

- Some may need to be contained by working on a tray

Sticky Paper Collage (Proulx, 2003, p. 118)

Proulx (2003) developed this activity for working with very small children and their parents in dyad work. We have also used it very successfully with the elderly and disabled.

Directive: This is a collage activity made easier for young children and the elderly by offering a sticky background, which is made by taking shelf paper and attaching it with masking tape to a tag or Bristol board. The artist/client can create an image by sticking materials onto the sticky paper provided. The frames can be decorated too. Have the sticky boards made ahead of time and present the activity with materials suitable for attaching to the paper.

Recommended Population: young children, people with disabilities & the elderly

Intention:

- To enhance self esteem and self mastery

- To create a situation where collage materials can be easily attached

- To facilitate self expression

- To overcome anxiety about art making

- To provide an opportunity for successful art experience for those with low motor control or inhibitions concerning art making

- To have fun and encourage spontaneity and creativity

- To provide an opportunity for creative decision making

Materials and Method:

- One sided sticky shelf liner roll, masking tape, Bristol board

- Sparkles or jello powder for very small children and infants

- Magazine images & coloured paper pieces

- Ribbon & feathers

- Any light weight materials that are colourful and/or textured

- Felt pens, bingo markers or stamps for decorating the paper frames

- To expand this activity further, one may want to paint or draw on the Bristol board around the image. Sometimes it is this extra final step that 'contains' the collage quite satisfactorily for the clients. This may be necessary, as these collages can get very loaded with materials. If participants are unable to hold a paintbrush, sponges are a successful alternative. Felt pens can also be used to create a patterned border.

Metaphor:

- Attaching and combining materials

- Putting the pieces together

- Telling stories

- Framing

Exploration:

- What was that experience like?

- Were there any surprises?

- Does it feel complete?

- What do you see?

- Are there any parts you like/ don't like?

- Does it have a title?

- Does it have a story?

- Are there related elements?

- Are there metaphors or symbols in the work?

- How does the client use narrative, if at all?

- Was there a variety of textures used or was it uniform?

Therapeutic Precautions:

- It could be very frustrating for the client if materials provided are too heavy to stick to this type of paper.

- Be forewarned that sparkles and sticky paper are going to be messy!

Sponge Painting & String Art

Directive: These are pre art activities that may evolve into more serious art making. Take a piece of string and dip it into the paint and hold both ends and make patterns on the paper by drawing, dropping, wiggling, and swishing it across the page. Try different colours. Use different sizes and shapes of sponges and an ice cube tray with paints, red, yellow, blue, white and black. Encourage colour mixing and experimentation with using a variety of painting implements like sticks or feathers.

Recommended Population: children, adolescents, adults & elderly.

Intention:

- To overcome anxiety around art making

- To enhance creative expression

- To provide an opportunity for successful art experience for those with low motor control or inhibitions concerning art making

- To build self esteem

- To have fun

- To engage and encourage spontaneity and creativity

- To provide an opportunity for creative decision making

Materials and Method:

- Paper & paint

- Sponges & strings (yarn or twine)

- Sticks & feathers

Metaphor:

- Abstract images can often lead into dialogue about feelings

Exploration:

- To look and see what is there

- To explore aspects of images through free association

- Ask the artist to describe the image as if the viewer was blind - the description will give places to explore the metaphors used in a more self-reflective manner.

Therapeutic Precautions:

Some artists may need to have some help to tape down paper onto a table. The string painting can get wild and messy with the string being used expressively to deposit paint on the paper. Try taping the paper to a wall or having it on the floor.

Feeling Lines

This activity has been adapted from Mala Betensky (1995, p. 31-43)

Directive: Going around the table, each person will say a feeling and everyone will draw a line to show what that feeling looks like to them.

Recommended Population: Children, adolescents, adults

Intention:

- To reduce anxiety around art making and art therapy

- To build a sense of group

- To explore the multitude of ways different emotions are felt and experienced and to encourage the development of emotional vocabulary

- To provide an opportunity for successful art experience for those with low motor control or inhibitions concerning art making

- To engage participants and encourage spontaneity and creativity

- To provide an opportunity for creative decision making

- To build self esteem and to have fun

Materials and Method:

- Large paper

- Newsprint or roofing paper

- Crayons, pastels, markers.

Put a large paper out to cover the group table. Each group member will say a feeling and everyone is to draw a line to represent that feeling.

This continues until you run out of feeling words or the paper is full. Make a group choice as to what to do with the paper next. It could become a large mural on a wall or ceiling.

Metaphor:

- Feelings as a foundation for expression.

- Size? Colour? Pressure? Body Posture? Facial expressions? Choice of feeling words?

Therapeutic Precautions:

Sometimes children in the group want to continue on the table picture expanding their lines. Others may move onto something else working on top of the large paper. Other times the group may decide it is complete and they would like it up on the wall. The use of one paper for the group serves to reduce performance anxiety.

Alternatives:

This can be done with individuals drawing their own lines on individual sheets of paper. The images can be compared to see what kinds of lines express anger or happiness. Also, in some situations, it might be best if the therapist chose the emotion words.

Dog in a Field

This activity was introduced by Dr. Bruce Tobin (1984) at the University of Victoria in a course in Expressive Therapies.

Directive: Take a large sheet of paper and a crayon or oil pastel. Close your eyes or move into a state of inner reflection. Imagine the crayon is a dog or any other animal entering a field or another place of choice, sniffing around, running this way and that. Maybe it sees a rabbit or smells a fox. Maybe it rolls in the grass or runs to a creek for a drink. Continue until your dog / animal decides to have a nap or go somewhere else.

Recommended Population: Children and adults

Intention:
- To build rapport
- To stimulate sensory awareness
- To extend the ability to explore
- To support ego development
- To reduce anxiety about art making

Materials and Method:
- Crayons, felt pens and/or pastels
- Large paper

Metaphor:
- To provide a metaphor for self exploration
- To encourage curiosity and play
- To introduce a sense of adventure
- To use the metaphor of a dog to explore needs, actions, fears, desires

- To encourage a range of body movements: loose, tight

- To increase enjoyment and comfort level

Therapeutic Precautions:

- Someone might find it foolish and demeaning.

Worst Pictures

Dr. Bruce Tobin (1984) in a course in Expressive Therapies at the University of Victoria, introduced the idea of utilizing a paradoxical approach to reduce anxiety about making art and to challenge the idea that art has to be "good" or "beautiful".

Directive: Try and create the worst picture you can imagine. Could be the worst picture of your favourite car.

Recommended Population: Children, adolescents, adults

Intention:

- To engage client in art making & to build relationship

- To emphasize process, not product

- To encourage spontaneity

- To ease any resistance & lower anxiety around art making

Materials and Method:

- Various sizes of paper

- Crayons, pastels, chalks, paints & brushes

Metaphor:
Once the "worst" picture has been created on purpose, there is no longer anxiety about unintentionally creating the "worst" picture. Also, the therapist has expressed interest and permission to express the "badness" one may feel is inside.

Therapeutic Precautions:
Some people, particularly those with issues with perfectionism, may not be able to take this directive. Also it should only be introduced informally as a way to get past a creative block, not as an end it itself.

Alternatives:

- Do pictures that are extremes of other elements. Ex: The "messiest" picture, the "yellowiest", the "smallest", the "simplest".

Chapter 11:

Individual, Conjoint and Group Art Activities

Cartoons

Directive: Create a cartoon character, an image or storyboard including word balloons and thought bubbles for what the characters are thinking and saying.

Recommended Population: Children, adolescents, people with disabilities, offenders.

Intention:

- To provide an opportunity for projection and identification

- To encourage an objective perspective from feelings and/or situation and to provide safety with distance and universality of cartoon characters

- To build self awareness and social understanding

- To distinguish between what someone might say and what they might be thinking

- To focus on developing appropriate communication skills

- To provide an opportunity for developing alternative narratives

Materials and Method:

- Assorted drawing and art making materials

- Collage images

- Variety sizes and colours of paper

- Magazines, glue, scissors

- Construction supplies for possible 3-D cartoon characters

Metaphor:

- Cartoons: anything can happen in a cartoon. They are not real; they are imaginary and make believe

- Sequencing, logical thinking before and after

- Projecting the future

Exploration:

- Distinguishing between what someone might be thinking, saying, or doing

- In what context is the image? What happened before this scene?

- What someone is saying in relation to what they are doing is very important.

Therapeutic Precautions:

It may be difficult to separate out what someone is thinking, saying, or doing. Anxiety and defenses may emerge, as the material may be disturbing.

Body Tracings

This activity has been developed into Body Mapping, which combines art and narrative therapy. (Lummis, 2008, Devine, 2008)

Directive: Lie down on a large piece of paper and have someone trace around your body. Before beginning the art, some of the following questions might be discussed or reflected on:

- How do you feel in your body?

- How do you perceive yourself?

- How have you been seen by others? How do you want to be seen?

- What lines, shapes or colours can you use to describe the energy in your body?

- Who are you, mentally, physically and/or spiritually?

- Do you wish to communicate the past/memories, the present, or the future/plans?

- What do you need (symbolically) to feel safe, to feel independent or to simply survive?

- What are your wishes and fears in life?

- Will you cut out your tracing, change its shape, apply words, create clothes, or create a background?

- What position would you like to represent? How should your body be positioned?

- What has your body experienced – injuries, illnesses, traumas and lived experiences?

Recommended Population: children, teens, and adults

Intention:

- To facilitate self expression

- To explore boundaries

- To establish safety and trust

- To promote self differentiation and individuation

- To gain awareness and regulation of boundaries

- To self reflect

- To explore one's relationship to one's body

Materials and Method:

- Large rolls of newsprint or black building paper or brown drawing paper

- Pastels, felt markers, crayons

- Magazine images

- Glue

- Sparkles, feathers

- Paint, paint brushes

- Scissors

Roll out large sheets of paper and have the client lie down on the paper in the position they want depicted. Trace around carefully keeping the crayon or felt pen perpendicular. Use a long pencil to reduce anxiety about drawing close to the individual. Paint, draw, or collage the image as you choose. The images (self portraits) might be cut out or a background might be painted in.

Exploration:

- What do you see?

- What stands out about the portrait?

- What has been added?

- What is around the outline of the body? Or was it cut out?

- Did you create metaphors and / or symbols?

- Did you represent your wishes and / or fears?

- Did you feel safe in the creation of the art?

- Any similarities or differences between self and image?

- Positive or negative presentation of self?

- Is it symbolic? Imaginary?

- What are the boundaries of self?

- How do you see the creation of self (ideal, perceived, or distorted)?

Therapeutic Precautions:

Some people may feel uncomfortable lying on the floor and the paper could be pinned or taped on the wall to be traced standing up.

Alternatives:

- This activity requires trust in the relationship. Be sensitive to the fact that some children may not want you drawing close to their body, especially between the legs. Let them draw the line in after. Or using a long felt pen can give you more distance.

- Use a light to create a body shadow on the paper on the wall to make shadow tracings.

Exercises developed by Florence Cane (1951)

> Art may be inspired by feeling and conceived in thought, but it is executed through the body. Thus the body is the instrument through which the creative process occurs. (Cane, 1951, p. 41)

Art has three precepts according to Florence Cane (1951) if it has reached its fullest expression. There is a correspondence between human functions and the principles of art:

1) The function of movement is related to the principle of rhythm (rhythm governs all the universe from the smallest atoms through human beings to the solar system);

2) The function of feeling is to create dynamics and harmony;

3) The function of thought is to create balance.

The integration of the individual through art is to activate and unify all one's human functions. To be creative is to have one's imagination free, to have the whole muscular and nervous system be alert and to respond to the heart. Awakening creative power is often prevented by the desire to create a "good picture" with a focus too much on product, which builds in the critical eye. Neither criticism nor constant praise favours creativity.

> Some examples of Florence Cane's exercises are (1951, p. 48-57):

1) Start with large body movements and breathe work to activate the whole body and then move to making large drawings on the wall. A key idea is that as art is a physical activity, physical warm ups are important. A drawing needs to start from the center of the body and move out through the shoulders, arms to the fingertips. Drawing does not start with the fingers.

2) Use a scribble or a loose string drawing to develop free association and perception. Leonardo DaVinci wrote of the value of looking at stains on the walls for inventing scenes and faces, etc. (Cane, 1951, p. 57)

3) In design done in partners, take turns making lines. Choose one colour and look to see which colour it begs for - then use only these two colours plus black and white.

See Cane's (1951) book *The Artist in Each of Us* for a thorough description of her approach. It is full of excellent ideas for enhancing the creative process.

Squiggle Game (Winnicott, 1971)

Directive: This activity is done with a partner or client. First each person makes a big squiggle on his or her paper and then exchanges it with a partner. Each person then draws what he or she sees into the image. Each person should talk about what was drawn and explain the picture - give it a title or tell a story.

Recommended Population: All populations, groups or individuals. This is a good activity to use in starting to build a therapeutic relationship.

Intention:

- To relax and encourage creativity and spontaneous responses

- To increase comfort level with art making process

- To enable unconscious materials and themes to emerge

- To reduce anxiety about how content emerges due the squiggle being someone else's

Materials and Method:

- Various sizes of paper and markers, crayons, oil pastels

- A series of drawings can be done and then looked at to see if a story emerges

Metaphor:

- To make a metaphoric story out of something as simple as a scribble.

Exploration:

- The spontaneous gesture allows the true self to emerge

- It is a symbolic way to recreate the importance of the infants spontaneous gesture being responded to by mother

- Coping strategies for dealing with ambiguity

- The possible emergence of a story/ narrative

- Associations with the final image

- Communication skills (observing, drawing, listening, responding)

- Implies the uniqueness of the individual's perceptions

- Provides an opportunity to model acceptance and respect

Therapeutic Precautions:

- If done individually with therapist, be aware of the content of your drawings

Alternatives:

- This game is similar to an individual activity in which the person makes a scribble and then expands the line into a full image (Cane, 1951, p. 56-61).

Scribble Tag (Tobin, 1984)

Scribble tag is sometimes referred to as a game of chase. Cathy Swanston (2004), a graduate of the Kutenai Art Therapy Institute wrote her thesis on the use of scribble tag with children who have witnessed abuse.

Directive: Playing "tag" with partners on paper. Additions of "safe spaces" can be incorporated and expanded to include what one might need in a "safe space". One cannot be "tagged" while in these areas.

Recommended population: All populations, certainly children. It is a good introductory activity for workshops.

Intention:

- To raise energy and encourage big arm movements

- To build rapport in the therapeutic relationship

- To relax, engage and have fun

- To reduce anxiety about art making

- To build a relationship of give and take

- To observe the individual's inner concerns and responses to others

Materials and Method:

- Various sizes of paper

- Crayons, pastels, markers

This game is to be played with partners or small groups of three.

It is similar to tag, except that the crayons or oil pastels get to run all over the page. The main rule is to keep your crayon on the paper and when you can touch the other player's crayon they become "IT". Children may adapt this game to include safe places and different rules. Follow their lead and become creative.

Metaphor:

- To be able to create and determine a safe place

- To create a framework of engagement, connection

- To work with the metaphor of moving in and out of a safe place

- To explore the metaphor of being touched and touching

- To observe the engagement metaphor of chasing and being chased

- To be able to play and respond to the other

Exploration:

- How did that experience feel?

- How were the safe spaces used?

- What differences were noticed when different materials were used?

- What role was preferred?

- What was the intensity of play? The aggressiveness? The passivity?

- What is noticed about the image?

- What were the patterns in terms of the use of space?

- Who used more space?

- How often did they use the safe spaces?

- What was included in the safe space, if anything?

- What was the participants' affect throughout the game?

- How did they interact with each other while competing?

Therapeutic Precautions:

It is important to attend to potential aggression or bullying within a group. Also, with young children it is the process that is important and it is not likely to be discussed afterwards.

Alternatives:

- Vary the sizes of paper from small to very large on the floor or wall

- Vary the materials from crayons, to markers, to paint

Areas for assessment identified by Cathy Swanston: (2004).

1) The child's sense of safety

2) The coping skills and defenses being used by the child

3) The child's strengths

4) The child's degree of ego strength

5) The child's sense of self

6) The child's concept of boundaries

7) Developmental issues evident

8) The child's current concerns.

9) Clinical issues for assessment:

 a) Indicators of sexual abuse,

 b) Attachment disruption,

 c) Anxiety,

 d) Post-traumatic play and on-going trauma.

Swanston's thesis is available at the Kutenai Art Therapy Institute Library.

Crayon Conversations (Tobin, 2001)

Directive: Using a full sheet of paper two individuals use crayons to develop a conversation. Each participant takes a turn making a line on the page. Either person can begin by coming onto the page from their side. When it is your turn again, continue your line from where you left off. Either player may quit by leaving the page. Let colour and quality of line say something about what's going on for you. You may change colour if desired.

Recommended Population: parent/ child, couples, children/ peers, new clients, teenagers

Intention:

- To enhance non-verbal communication skills

- To build empathy and rapport

- To practice listening skills through observation

- To function as an icebreaker and as a tool that can lead to depth work

- To communicate without words

- To make visible the interpersonal dynamics

Materials and Method:

- Any size paper & crayons or oil pastels

Metaphor:

- For couples and parent and child dyads, the page may represent shared "life" space/world

- Relationship styles: our dynamic patterns of interaction,

- Communicate about communicating without the content.

- Responsiveness to non-verbal communication

Exploration:

- What was this like to do?

- What did you learn or notice about your style of relating?

- What does the following say about how you relate and communicate?

- Space: who takes the most?

- Amount of deliberation or spontaneity with your response?

- Initiative: who spends the most time following? Leading?

- To what extent is initiative shared?

- Do the lines become shapes or boundaries?

- What roles are taken?

- Making contact: how much? How close? Who initiates?

- What is it like before/after? Is chase better than catch?

- What do you do with intimacy? Struggle? Compete? Cooperate? Play? Dance?

- Who begins and ends the relationship?

- General style: avoiding? teasing? intrusive? aggressive?

- Degree of interactivity: how much does one line depend on the other line?

- Degree of comfort in crossing other's lines.

- Use of space is a metaphor for closeness and distance (intimacy): How much is too much or not enough? What do you do with intimacy?

- Artistic Aspects: line quality - heavy, tentative, bold, confident, shape, symbols.

Therapeutic Precautions:

- May cause anxiety

- Challenge to move into non verbal communication

- Has the potential to intensify and make visible problematic communication patterns

Alternatives:

- Both people drawing at the same time

- Take turns dialoguing with symbols

- Make a line and give voice to the communication

- When your partner makes a line, state what you understand it to mean

- Try with more participants, as in a family

- Start wherever you like on the page

- A version of this turned into an art game of attack and defend with a group of teen boys

- You do not have to restart your line each time where you left off.

Race Track Drawing (Tobin, 1984)

Directive: With your client, decide on the kind of racetrack: car racing, steeplechase, bicycle, foot race, rabbit, skiing, horse, potato sack, triathlon. Ask your client questions that will expand the art making activity as it is created. Include not only the track but also the surrounding area: stands, trees, people, snack booths, water holes, race obstacles, etc.

Draw the image together with dialogue. Draw the racers. Put your crayons on the racers and race. Take time to include all the details you would like. Decide sizes, beginnings and endings, other aspects of the track environment, necessary things for racing, obstacles in the tracks, and trophies. Naturally the younger artist is more likely to win the race, however they need a good run for their money.

Recommended Population: parent / child dyad, or therapist with child

Intention:

- To build a relationship

- To support ego development

- To enhance social skills, taking turns, dialoguing

- To support attachment and positive interaction with parent and child

Materials and Method:

- Pastels, markers & crayons

- Strong paper

Metaphor:

- To create a game together and to play together

- How does it feel to win or lose?

- What else can be added? How can it be expanded?

- What was the intensity of play? Aggressive? Passive?

- What is the attitude towards competition?

- What was the enthusiasm level?

Therapeutic Considerations:

- Paint and newsprint is not recommended for racing as it tears too easily.

- Be sure to respect creation all along the process - some may not want to race or draw on their image in the end.

- When the therapist loses, model a healthy response to the feelings of not winning.

- Work with the feelings and dialogue if the parent is aggressive and is winning all the time.

Bridge Building

Directive: First create a symbol for yourself. This is usually done in clay. When the self symbols are finished, build a bridge together as a group. The group should decide where the bridge is going to and where it is coming from. When the bridge is complete, each participant is to place his or her self-symbol where they feel they are in relationship to the bridge.

Recommended Population: adult groups, families, dyads: parent & child, children & peers, team building.

Intention:

- To build connection within a group

- To explore cooperation and group dynamics

- To strengthen problem solving skills as a team

- To explore self in relation to others

- To create a dialogue about transitions; about moving one state of being to another; from one place to another. How do we get there? What are we crossing over? What will the bridge be made of?

Materials and Method:

- Clay and objects for construction – wood, cardboard.

- Glue gun & white glue & masking tape

- Large newsprint or building paper to cover work areas

- Paint & brushes

- Water for clay & paints

- Black paper or cardboard base

Allow appropriate time for self-symbol creation. Invite the group to create a bridge. Incorporate the symbol of self into co-creation.

Encourage dialogue in the group regarding metaphors and symbolic meaning.

Metaphor:

- To represents a transition in life

- To provide abundant opportunities for the development and expression of personal metaphors: transitions in life.

- To explore inter-group or family dynamics

- To illustrates problems, strengths and communication patterns

- To enhance flexibility, creativity, and innovation

Exploration:

- Where does the bridge come from?

- Where is the bridge going?

- What was the process like?

- Did leaders emerge in your group?

- How were decisions made?

- What was your personal involvement and investment?

- Where did the artist place his or her self symbol in relation to bridge?

- What is the sturdiness, safety and accessibility of bridge?

- What is on either side of the bridge? How do you get on and off?

- What kind of bridge is it?

- What is underneath the bridge?

Therapeutic Precautions:

Group dynamic problems become very evident. Power struggles or dominating group members may need some reflection during the process. After the exercise, facilitate dialogue about people feeling their ideas were being valued or not. Ask how the group made decisions? Did a leader emerge? How did that feel? Some participants could have passive-aggressively withdrawn or could take over insisting on their own vision and or needs. Reflect on the process with the participants.

I suggest you give each member a small piece of clay for his or her self symbol. If they want more they can have more, but if you give a large ball of clay you are likely to get very large self-symbols, which will be difficult to place on the bridge.

Murals

Directive: There are many ways to create a mural. It can be a positive group building activity. It is important to decide on the process and theme even if it will be abstract or spontaneous. Be sure to discuss whether or not it is okay to go over or touch others' contributions. Sometimes at the ending of a group I give a directive to use up all of the paint on a large circular mural (made by taping paper together).

Recommended Population: Groups of any age or community events.

Intention:

- To support a fun group activity for events within community

- To build group connection

- To practice co-operation & to have a positive experience

- To have an opportunity to learn appropriate boundaries

Materials and Method:

- Large paper: newsprint, building paper

- Paints & brushes

- Crayons, pastels, chalks, markers

- Canvas and acrylic paint optional (could be done as a floor cloth)

Metaphor:

- A group coming together to create a unified single image.

- Working together

- A visual product as a result of co-operation

Therapeutic Precautions:

Group dynamics: some participants may be controlling and aggressively territorial while others may be passive and withdrawn. It is important that all participants have an opportunity to contribute their creative ideas.

Alternatives:

- Check in for group session, graffiti wall, draw an island (Riley, 1999)

- Hand prints or cut outs of traced hands placed on to a mural as either a starting or an ending activity.

- Create a World – large group construction to create - an ideal, fantasy or real world. (Rhyne, 1984)

- A large mandala can be done as a closing activity.

- Use the feet to paint a mural on the floor. Spread paper all over the floor and having the participants use their feet to create an image together. Play music. (Siano, 2004)

- Create individual painted or drawn images of trees. Cut them out and place on a large sheet of paper to make a forest as a group. (Siano, 2004)

Chapter 12:

Art Making to Look at The Self

A Self Map

This directive has been adapted from a social atom drawing introduced by the feminist art therapist Leigh Files at an Art Therapy conference in Vancouver in the late 1980's.

Directive: Draw a self-map. It is a map of one's life at this moment in time. Draw the map to represent how you feel today at this particular moment in time. Tomorrow you might draw a different map with different feelings. This is an opportunity to take stock of your life at this time. Start with a symbol for yourself and then draw symbols or images for the people or animals and activities in your life that are important to you. The people may be dead or alive, present or far away, positive or negative connections. Symbols can be simple (a circle, a square, or a line), or complex. They can be narrative, figurative, analogical, or metaphoric. They might be animals, objects, or colours. It can be a constructed symbol or known symbol. It can also include activities, places, connections, or separations.

Recommended Population: adults, adolescents - it can be done in a group or individual session as an initial activity or as a focal point to assess therapeutic progress. It can be used as a way of introducing yourself to the therapist or the group.

Intention:

- To introduce a model of metaphoric thinking;

- To focus and reflect on oneself and context;

- To develop a personal dictionary of symbols and colour

- To begin a process of self exploration;

- To provide an opening exercise for getting to know new clients in individual or group work.

Materials and Method:

- Oil pastels

- Felt pens or coloured pencils

- Small or large paper

Generally speaking, it would be appropriate to start with materials that will give more control and structure to the image making. A choice of large or small paper could be given to the group or, depending on the amount of time and the size of the group. This directive could certainly be offered with paint or even clay. The choice of materials would depend on what stage the individuals in the group are in their therapeutic process.

Metaphor:

This directive can be symbolically intense and have many layers of self-reflective significance. There are always lots of thoughts and ideas that have come to mind while drawing.

Having the image held up or put up on the board can be a very intimate experience. Sometimes people prefer to hold it up but not speak about it. This is a first step. We can see what has been drawn. We can see how they see themselves and their place in the world. They may wonder: How will I be perceived? Will I be accepted? Liked? Respected? The image should be looked at, honoured, accepted and respected. Often when an individual finds that they are accepted the way they are, they feel more like speaking - in fact, they may have a lot to say. Sometimes people are surprised that tears come up when they start to speak - or they are afraid that they will. Let them take their

time. When they are ready to share, they will. Remember that therapy is a long-term process. It takes time to build trust; sometimes it takes longer if the individual has had disruptions in the first years of their life, during the trust/mistrust stage. (Erikson, 1987) It is never a good plan to push at the beginning; nothing is gained. People will either just push back or get scared and flee emotionally. It is important to remember that the therapeutic process is theirs and they need to be in charge of it. It is their work to do. This is the way that change will occur at a deep level and not just be a change of behaviour.

Start the initial dialogue by asking if they would like to talk about it, or if they would like to share their story or image with the group. The questions can be simple: Would you like to put it up and stand back and have a look at it? What do you see? Would you like to talk about it? Were there any surprises - things you noticed that you hadn't planned? Is there any part that you haven't commented on?

The art therapist should make a statement or reflection of what has been shared. Pay attention to closing: "Is there anything else you would like to say?" Remember to thank and acknowledge the individual. Always remember that it takes a lot of courage to speak of one's personal life.

Therapeutic Precautions:

- Has a tendency to take people deep quite quickly

- All key issues are generally in the map

- It might be too threatening for a group or individual that wants to stay light and focus on creativity

Alternatives:

Create a three-dimensional self map either as a sculpture, mobile, or box

Socio-gram

Description: A family map: a drawing in which each member of the family is depicted as a symbol or a circle, to represent the artist/client's perceptions.

Directive: Draw a symbol of yourself on the page in relation to the center. Use symbols to arrange all other family members in relation to you. Use size to show importance, use distance to show levels of intimacy. Decide where you are in the family: in the middle? Out on the fringe? How close to the center of action? How is communication depicted?

Connect each person with a line: the quality of the line will represent the nature of relationship, thickness, pressure, colour, type: dotted; zigzag, double, jagged.

Draw arrows to indicate whether in each relationship people are moving closer or farther away. No arrow indicates that there is no movement.

Shade each person, including self, to indicate amount of positive regard you have for that person – indicate through external shading the parts that you are dissatisfied with.

Recommended Population: Family: adolescents & adults

Intention:

- To create their own subjective genograms

- To discover insights regarding self attitude toward family

- To explore patterns within the family

Materials and Method:

- Paper & crayons/ pastels/ markers

Exploration:
A. Process:

- What was it like to do this family map?

- What was the easiest? Hardest?

- Any resistance? Why?

- What was the process of drawing- the sequence and intensity?

B. Content:

- Who's who?

- Place on page relative to middle?

- Size of symbol: relative power in family?

- Meaning of symbols?

- Shaded portion: self-esteem & other's esteem?

- Relationship lines?

- Arrows: moving closer or farther apart? Staying the same?

- What specifically would you like to see different in the family?

- What can you do to create the desired change?

- What would it be like to share this with other family members?

Therapeutic Precautions:

- An intense focus on family may bring up anxiety & resistances.

- Be sensitive to how their defense mechanisms appear.

Alternatives:

- Draw a socio-gram from the point of view of other family members.

- How much congruence of perceptions is there? What accounts for discrepancies? What do discrepancies indicate?

- Draw a socio-gram to indicate how you would like the family to be.

- It could be enacted with people and made into a living sculpture.

Life Lines

Directive: Take a coloured pencil crayon or felt pen and a big sheet of paper. On the paper draw a line in a shape, which represents life from birth to the present. Then fill it in with shapes, colours, symbols, images and words, to represent the different events or situations, which stand out in the life noting the highs and the lows.

Recommended Population: Pre–teens, adolescents, adults

Intention:

- To provide an opportunity to reflect on life

- To offer a chance to realize an alternate perspective

- To see life as a whole

- To gain insight into self view of life

- To emphasize continuation of life

Materials and Method:

- Coloured crayons, markers, pastels, crayons

- Large paper

- Magazines, glue, scissors

Metaphor:

- A time line containing happenings in life

- Creating your own history

- Recording a legacy

Therapeutic Precautions:

- Some people may feel uncomfortable having their entire life drawn out before them.

- They might experience intense emotion in response to possible connections, patterns, or insights.

Alternatives:

- Create the lifeline in a circular formation, or as a brain wave or a road map.

Kinetic Family Drawing (Burns, 1982)

Directive: Draw a picture of your family either your current family (Kinetic Family Drawing - KFD) or your family of origin (Regressed Kinetic Family Drawing - RKFD). Draw each family member in action - people with bodies, not stick people.

Recommended Population: Families, children, adolescents.

Intention:

- As an assessment of family dynamics

- Opportunity to explore conscious and unconscious family dynamics

Materials and Method:

- Paper

- Crayons, pencils, oil pastels

Exploration:

- Who is in the family? Anyone missing? Why?

- What is each doing in the drawing?

- Allow the individual to look, reflect and explore the image in depth.

- Why have you drawn each one as you have?

- How do family members relate?

- Closeness/ distance?

- Roles: How was it established? How do others feel about it?

- Rules: How are they made? By whom? How are they changed?

- Communication styles: assertive, aggressive, and submissive?

- Boundaries: who's in/ out

- Alliances? Coalitions? Affiliations?

- Centrality? Isolation?

- Blocking behaviours?

- What would you like to see different in the family?

Therapeutic Precautions:

- Drawing the image may be easier than talking about it afterwards because it takes you immediately into the self reflective zone

- This directive may bring up a lot of unconscious material. Family secrets may emerge. Deep-rooted feelings may become visible.

Alternatives:

- Redraw picture as the ideal family

- Family members as trees, jungle animals, flowers

- A regressed kinetic drawing for adults: choosing an age and doing a kinetic family drawing at that age. RKFD

Fairy tales

Directive: Draw a scene from your favourite fairy tale.

Recommended Population: Children, adolescents, and adults

Intention:

- To encourage individuation

- To facilitate self expression

- To enhance self awareness

Materials and Method:

- A full choice of art materials

Metaphor:

- The image is likely to be laden with symbolic context.

- Depending on the fairy tale, the focus might be individuation or it might be how to manage evil.

Exploration:

- What happens in the particular fairy tale, especially in this depicted scene?

- Exploration of the different characters and symbols.

- Amplification of feelings and metaphors. Have you ever felt that way?

- What part do you like the most? The least?

Therapeutic Precautions:

For adults it may be safe to go to self-reflective dialogue, but for children it is best to stay with the concrete and metaphorical. Relating self to fairy tales can be very intense and personal. Follow the client's lead.

Alternatives:

- Depict a myth or fairy tale that is important to you in some way.

- Read a fairy tale or myth and have client draw an image.

- Draw your life in terms of a myth or fairy tale.

- Make a fairytale book – either make up your own fairytale or illustrate one that you remember. This can be a sculptural book or construction.

- Do a series of paintings to explore a myth or fairy tale. Try to amplify a symbol of character from your painting. Explore interpretation symbolically, psychologically and with personal relevance.

Trees

Directive: A simple directive to draw a tree can lead to a lot of self-reflection, as it is likely that the tree becomes a metaphorical self-portrait. This suggestion is well suited to going carefully through the three different kinds of questions; concrete, metaphorical, self reflective as outlined in Chapter 1.

Recommended Populations: Children, adolescents, adults

Intention:

- Self reflection

- Using a tree as a visual metaphor

Materials and Method:

- Paints & brushes

- Crayons, pastels, markers

- Paper, various sizes and colours

- Magazines

- Scissors, glue

Metaphor:

- Metaphor of growth

- Metaphorical self portrait

Exploration:

- What kind of tree is it?

- Where does it grow? What surrounds it?

- Can you describe the trunk and the root system?

- What season of the year would it be? Fruits? Function?

- Explore positive as well as problematic aspects of the image

- What kind of a tree would you be?

- How old? How big?

- Where would you be growing?

- What is the environment like?

- What time of day?

- What is the weather currently like?

- What kind of soil are you growing in?

- Are you near water? Are you near other trees?

- Are there animals or birds in the tree?

Therapeutic Precautions:
Using a strong metaphor can evoke deep insight.

Alternatives:

- Go outside and find a tree to identify with.

- Hand Print Trees

- With a group or with individuals, create the trunk of a tree and attach it to the wall. Everyone makes cut outs of their handprints or hand tracings. These will be the leaves to be stuck on the tree.

- Family Trees could be done as a parent/ child dyad. Together create a background. Individually create a tree for yourself. Together place the trees on the background.

Relationship Mandalas

This exercise was introduced by Dr. Bruce Tobin at KATI in 1996.

Directive: Create two mandalas on the same page. Draw one mandala to represent yourself, and the other to represent another person. This exercise is to be done in two parts. The first two mandalas are to express the relationship as it actually is. On a second paper, draw the next two mandalas to express the relationship as you would like it to be (ideal). Create on the inside of the mandala how you feel on the inside, and on the outside how you express yourself to the other. For the other person's mandala, express how you think they feel on the inside and how you experience them on the outside. You can show how the mandalas relate to each other through size, closeness and in the image.

Recommended Population: Couples and Families. It can also be useful for an individual exploring relationship dynamics. It can be used in supervision to explore the relationship between a client and therapist.

Intention:

- To explore the personal relationship with another

- To facilitate development of definite and flexible boundaries

- To discover the degree of discrepancy between partners' perceptions

- To work towards a consensus of view points

- To encourage authentic expression within the relationship

Materials and Method:

- Paper

- Circle makers

- Paints & brushes

- Pastels/ crayons/ markers

Supply a variety of art making materials. Facilitate the making of mandalas, and follow the directive. Have some different sizes of circle templates to choose from.

Metaphor:

- Mandalas are structured enough to give direction, yet open enough for expression.

- Two images on one page = paradigm of the whole

- Interaction with each other

- Searching for common ground of agreement

- Repeated imagery & importance of expressing needs, hopes & wishes.

- Body language while creating art

- Distance represents emotional distance or intimacy

- Boundaries: the rigidity, permeability

- Size of mandala - represents the degree of power in the relationship

- Perimeter distinction between the outside and core. Let the outside represent the public persona

- Let the inside core represent the inner private self

- The page as a whole can represent the shared life space for the couple

- Colour can represent emotion

Exploration:

- What things get in the way; what keeps the relationship stuck

- What is working

- Commonalities and differences

Therapeutic Precautions:

- Be available for any heated discussion that may occur throughout the art making time.

- Emphasize the safety of the therapeutic session, as the couple must also continue interacting outside of the session.

- This exercise should only be introduced by a therapist with training and experience in couples' art therapy.

Clay work

Clay is a very powerful media to work with. However, it can be messy physically and it can bring up some of the messy feelings. There are a few ideas for working with clay in office environments. You might try using rag rugs under the table to catch water, clay or plastic tablecloths. Newspapers may be important unless you have some easily cleaned surfaces. Cafeteria trays can be useful for containing water and clay. Some easy clay tools are old toothbrushes and an old garlic press, which can make great 'hair'.

Self Symbol in Clay

Directive: Take a piece of soft clay in your hands and close your eyes if you feel comfortable. Take your time to feel the clay and allow a shape or symbol to emerge. This could be a self-symbol or a self-portrait if you wish.

You could direct yourself to think of other aspects of life, specific aspects of self, family, other, a question on your mind, etc. See what emerges out of the clay and free associate to the symbol or image that spontaneously emerges.

Recommended Population: Adults

Intention:

- To self reflect and encourage centering and grounding

- To emphasize process of art making

- To encourage creative self expression and to provide sensory stimulation

- To bypass cognitive defenses and reduce intellectualization

Materials and Method:

- Clay and water dishes for everyone

- Close your eyes for ten minutes and work with clay to discover what emerges

Metaphor:

- We can create ourselves

Exploration:

- Describe the piece. What is its overall feel? Tone?

- Does it remind you of anything?

- What qualities of the piece do you identify with?

Therapeutic Precautions:

- Some people will not be comfortable closing their eyes - do not insist.

- Some people might have difficulty getting hands dirty. Rubber gloves can be used.

Earth Art Therapy Activities & Practices

Take art therapy into the natural environment:

- Create environmental art: create art out of natural subjects/objects and in relationship and dialogue with nature.

- Create sand sculptures or draw pictures in the sand.

- Create a mandala on the earth and use natural materials.

- Create art in nature within the context of therapy.

Bring nature into the art therapy space:

- Create art.

- Write poetry.

Be environmentally conscious with regards to materials:

- Use recycled materials. Collect assorted recycled materials from individuals and businesses

- Use non-toxic materials

- Use natural materials: feathers, seeds, leaves, petals, pebbles, etc.

- Create reusable surfaces like a chalkboard for scribble tag

- Use dirt or mud for art making.

Bring art making and therapy into environmental programs:

- Sit in nature, listen to sounds and attend to all the sensory input.

- "Trust walk" in nature. This is done in pairs with one person blind folded and being lead around and introduced to nature.

Bring nature into art making and studio work or go into nature and create art:

- Blind Contour drawing of natural objects.

- Sketch or paint in nature.

- Look for the shapes and shadows in nature – draw what is not there – draw the negative space.

- Create a sculpture or installation in the environment.

Paint a found rock as a transitional object (Robertson, 2005, p. 40):

- Painting rocks, sticks and driftwood.

Draw or paint on pieces of cloth to make a flag:

- A personal flag for climbing a mountain (Robertson, 2005, p. 38)

- A prayer flag - Tibetan prayer flags

Explore a sense of belonging to a place by using maps as a basis to create collage images. Maps can be used in a number of ways:

- Memory maps:

- Choose a map to explore the memory of a special place from your childhood.

- Create a landscape or map from your childhood (between 6 to 9 years old).

- Follow it with one from the ages 9 to 12 years old.

- Cultural maps:

- Choose a map to represent your home country. Use the map to identify and describe your ancestry, where they came from, when they arrived in this region, how they earned their living, what the region looked like when they first arrived, how it looks now.

- Relationship to environment:

- Choose a map to express your experience of a disturbed place in the environment.

- Create a construction that gives expression to an archeological dig at a special site from your memory.

Explore natural metaphors and meanings:

- Explore or walk in nature; bring in something from the natural environment and create art or poetry in relationship to it.

- Collect natural items. Create art with the objects or photograph them in the environment.

- Find a symbol in nature and explore its meaning in a personal manner.

- Work with the elements: earth, water, air, and fire.

- Explore in art and words metaphors of animals, insects and birds.

- Use collage images of nature to explore personal meaning and metaphor.

Explore a sense of relationship or belonging in Nature:

- Photograph yourself in nature and photograph natural forms to reflect on.

Make contact with self & other and reintegrate disowned parts of the self:

- The focus is on renewing the capacity for wholeness and rebuilding a positive relationship to the environment. In all of this work there is an emphasis on paying attention:

- Attention to breathe and the rhythm of breathing. We exchange air with plants, animals, birds and other people. Keep the balance of attention with breathing in and out as a movement from the self to the outer world.

- Build awareness of the relationship between subjects - the nature of boundaries and ways of touching, permeable and impermeable boundaries, flexible and inflexible, rigid or flowing.

- Look at the relationship of parts to a whole: patterns of blocking and fragmenting.

- Expand perception to increase tolerance for diversity and to increase understanding.

Animals

Directive: Think of an animal, imagine it, smell it, inhabit it, create it in the art. Create that animal and make a habitat for it.

Recommended Population: children, teens, and parent-child dyads

Intention:

- To promote self differentiation

- To permit safe expression of relationships

Materials and Method:

- Plasticine or clay

- Construction materials

- Drawing and painting materials

- Assorted paper

Metaphor:

- To amplify the animal symbolism

- Symbolic animals can pertain to Id energy and explorations (animal bridegroom, helpful animals)

- Helpful animal motif.

- The animal's negative and positive qualities.

Exploration:

- What do you see?

- Physical/ biological: what do you know about this animal?

- Social/ cultural: what are beliefs, myths, and cultural views of this animal?

- Personal: symbolic meanings

- How can our animal nature help us on our journey?

- A gestalt approach - give an "I" voice to each animal-describing self

- Other aspects of the art: figure/ground context

- Relationship between animals

- Self reflective: how do all these ways of viewing, explaining the art and associations relate to one's self and one's present concerns in life

Therapeutic Precautions:

- Some people may have had traumatic experiences with animals.

Alternatives:

- Explore an animal that you like & one you are afraid of

- 3- D construction with papier mache

- Create your family as animals using clay, plasticine, drawing or painting.

Exploration of the concrete aspects

For animals this would include: size, position, colour, realism, biology, habitat, behaviour, species, nature (wild or tame, dangerous or friendly), function and relationship to other animals and to people. Concrete aspects would include the animals' survival skills and what they eat or need for survival. The art object itself and the artist's commitment to the work is also part of the concrete level for consideration –which may be shown by the amount of time and care taken.

Exploration of the metaphoric aspects

The metaphoric aspects of the animal might include looking at the symbolic and cultural meanings for the different animals. This could include stories, myths, fables, and proverbs. An example could be the relationship between a mouse and a lion.

Exploration of the self-reflective aspects

The self-reflective aspects will consider the relationships between animal family members - looking at similarities and differences and the significant qualities that are expressed. It is important to keep the dialectic in mind and reflect that qualities described can be seen on a continuum.

Self-Reflective Evaluation Practice

This exercise was developed by Regina Cowan and introduced at the CATA conference 2006, in Toronto. She developed it for nurses doing annual self-reflective evaluation. The intention is to assess for: strengths; areas for development; professional gaps; and to determine the current needs for professional development.

The use of art making in reflective practice will provide a creative engagement that can bear witness to possibilities and challenges. Visual art can provide the concrete experience of both engaging and reflecting on areas of personal practice. It can serve to acknowledge both strengths and challenges and it can affirm the individual and provide guidance for future development.

The activity is to make a Collage using a multitude of pre-cut diverse images. Use ONE sheet of paper. The goal here is not to separate out aspects in the way a medical model might, but to see all aspects simultaneously and in relationship to each other.

Follow the five prompts, which are to be given one at a time. Leave time to collect and attach images on the paper before the next prompt is given. The direction is to choose images intuitively rather than attempt to illustrate. Cowan (2006) used a lovely phrase to direct participants in selecting collage images: "To look with the eyes of your heart."

The five prompts are:

1) What is most important to you now?

2) What is it like to be in this situation?

3) What do you hope happens?

4) Who or what might help you right now?

5) You are being given an important gift – an answer to your prayers – what is it?

Write a short fable or fairytale that starts and includes the following beginnings of sentences.

Once upon a time a _____ (woman, art therapist, man…)

What she needed to know was _____

The answer she found was _____

Then using a small piece of paper, postcard or tag, formulate a mission statement.

Create a mission statement that doesn't have words. Look in the collage to find an image that is a metaphor of the mission statement.

From Art to Poetry: Let your Image find its Voice

Directive: Create art. This can be spontaneous art or focused on a theme. Look at the art and write a description. Don't do an explanation or interpretation, but a description of what you actually see. From the description, take each aspect of the art and write a statement in an "I" voice. This part of the process serves to enhance the meaning and intentionality of the artwork. Write a poem in response to the art. This is thought of as distilling the essence.

Recommended Population: Adults

Intention: To encourage the development of self-awareness and self-expression.

Materials and Method:

- Drawing paper

- Some writing paper or drawing paper to write on

- Oil pastels (minimum) or a choice of materials: chalks, felts, etc.

- Assorted art materials - the exercise is often done with the full spectrum of paints etc. but it is not necessary.

Metaphor:

This experiential workshop will introduce an art therapy exercise designed to integrate the phenomenological method with gestalt art therapy and poetry. Its focus is to bring the creative act into language with a movement from creating an image to writing poetry. The intent is to uncover hidden essences, to release the poetic voice and to make a translation from the visual image to the written word and to the voice.

Exploration:

In the closing circle there will be an opportunity for individuals, if they wish, to read their poetry and show their art. This brings the individual and their creative process into context or what would be

called being-in-the-world. Accept and honour everyone's art and poetry. The poems are often very powerful. Don't insist if someone does not want to share. Silence can be an expression of respect.

Being-in-the-World

This exercise was introduced by Deborah Linesch, at a CATA conference, Toronto, 1996. I gave it the title after using it with my students several times.

Directive: Take 3 sheets of paper and cut one in half. Cut one of the halves in half. You end up with 2 full pages, 1- 1/2 page, 2- 1/4 pages. On the smallest piece create an image of your self. On the half page piece create an image of your "family". On the full page create an image of your "community". Once you have finished the images, place them one on top of each other and dialogue in a dyad about the image. Choose a section of the image that catches your attention. The witness in the dyad should initiate this part. Take the third full page and rip a hole in it. Place this page over your artwork so that the part you chose to focus on can be seen through the hole. Re-create the image, as you would like, using this layered image.

Recommended Population: adults and adolescents

Intention:

- To explore priorities, gifts and sacrifices in life

- To explore oneself in relationship to one's family and community

- To rediscover your value system

- To focus on specific aspects of self in relation to other

Materials:

- Three pieces of paper

- Scissors

- Pastels, markers, crayons, paints & brushes

Exploration:

- What was it like to overlap and combine images?

- What part really stands out to you?

- How were directions followed?

- What level was the attention to detail? Very meticulous? Vague?

- What were the narratives and metaphors used when dialoguing about family, self and community?

Metaphor:

- Self in relation to world & other

- Covering, choosing, prioritizing, reframing, refocusing

Therapeutic Precautions:

This is more appropriate for students and professionals interested in personal growth and self-understanding and individuals with a strong sense of self. Could be used in an individual session for an adult client wanting to look at themselves in relationship to their families and work on community.

The Problem as you see it: a gestalt activity

This directive comes from the gestalt art therapist, Janie Rhyne. She introduced it in a workshop given in Victoria shortly before she died. It is, I believe unpublished.

Directive: Create four images on four separate sheets of paper. 1) The problem as you see it 2) hopes and wishes about problem 3) worst fears about problem 4) I wonder if....

Recommended Population: adults or older teens.

Intention:

- To develop a visual perspective on the "problem"

- To explore fears and anxieties pertaining to the "problem"

- To express your hopes and wishes with regards to the "problem"

- To explore other alternative solutions

- To perceive the problem as a whole in an expanded form

- To use cognitive problem solving

- To use art to address and gain insight about the problem

Materials and Method:

- Paints & brushes

- Crayons, pastels, chalks

- Various sizes of paper

- Magazines, glue, scissors

Exploration:

- Put the four images up on the wall in the form of a medicine wheel or like a cross

- Use art as a springboard into dialogue of problem

- Explore using an "I" voice.

Metaphor:

- To get different perspectives of the same problem

- Projecting the problem onto the page may shift a perception allowing new possibilities to emerge.

Therapeutic Precautions:

- Client needs some ego strength to focus in this way.

Alternatives:

- Can be applied to any number of issues, themes, or concerns

Chapter 13:

Different Art Media used Therapeutically

Puppets & Puppet Theatre

Directive: Create a puppet or several puppets. They could be people, animals, wise characters, or even dangerous or evil characters. Expand the activity to include a house, environment, or theatre for the character/s.

Recommended Population: children, adolescents, adults

Intention:

- To provide an opportunity for emotional expression and insight.

- For pleasure and relaxation

- Playing out inner or fantasy world.

Themes for puppet plays can be developed out of group discussions. It may be easier to explore conflicts and be objective about them through the projection of roles. Puppets allow for some degree of anonymity. Conflicts can be relived as archetypal forms. They promote interpersonal relationships and personal initiative. Client participants may be more comfortable due to concealment with the use of the stage.

Materials and Method: (Materials will vary depending on style of puppet).

- Cloth, yarn, needles & thread

- Construction materials: toilet rolls, egg cartons, Popsicle sticks, sawdust

- Paper mache, model magic, sculpty, white glue

- Acrylic paint

- Glue & glue gun

Lani Gerity's Puppet Instructions

Materials and Method

- Use as much recycled stuff as possible!

- The head can be made with paper- mache, model magic or bread dough. Gerity introduce a method of combining bread dough, glue and detergent. The heads take most groups under an hour to make. You can bake paper- mache in the oven for a few hours at 200F, leaving heads in the oven to cool.

- Yarn for hair can be attached with a hot glue gun or fabric glue.

- Eyes, nose, mouth and ears can be added on or carved into modeling material. (For extra texture, cover head with thin paper and decoupage glue)

- Take two pieces of cloth and cut roughly a mitten/ body shape. Make sure to cut it about an inch wider than your hand all the way around. Put a running stitch around the edge, leaving the bottom open for your hand. Attach head and body with glue. The bodies take a little longer than an hour.

- Painting and decorating takes two fun hours at least. Acrylic paints will add strength to sculpting material.

Metaphor:

- Externalize aspects of self and others

- Role play & fantasy

- Personification

- Projection of feelings of "badness" or "goodness"

Exploration:

- What was it like making a puppet?

- What were your initial plans when you started the puppet?

- Has your puppet changed?

- Who is your puppet?

- What does it like to do or say?

- Where does it live?

- Does it remind you of anyone?

Therapeutic Precautions:

- The young might need help with the needle and thread.

- Groups can be mixed abilities

Alternatives:

- Shadow puppets, rod puppets, puppet theatre and shows (scripts: client written, therapist written, collaboration, fairy tales), sock puppets, hand puppets, finger puppets, sawdust stuffed puppets

- Hard puppets can be made with egg cartons or pie plates with a hinged cardboard mouth taped on.

- Finger puppets can be made with cloth or toilet paper rolls.

- Create puppet shows, narratives, journeys, and fairytales.

Masks

Directive: Masks can be made with a variety of materials. Paris craft (plaster bandages) allows the artist client to have a mask made of his or her own face. The material allows a mask to be made of a face using the face as a mold. It can be a full mask, or a half mask. The eyes can be open or shut. The mask can be painted and decorated any way the artist wants. Sometimes the suggestion is made that it could be decorated on the inside to reflect how the artist feels on the inside and the outside can reflect how the artist feels on the outside, or how the artist wishes to be perceived on the inside or outside.

Recommended Population: Children, adults, adolescents

Intention:

- To self reflect

- To discover another aspect of self

- To build self esteem

Materials and Method:

- Paris craft, plaster, water trays

- Scissors

- Paints

- Glue gun

- Fabric

- Beads, sparkles, feathers, etc.

The client will need to have Lubriderm cream or Vaseline on the skin that is going to be covered by the mask making material. The hair around the face needs to be out of the way and facial hair covered by cream. This may be done by either the clients themselves in the case of adults or by the therapist in the case of children requiring nurturing.

Make sure nostrils are not covered. A plastic shower cap can be helpful to protect the hair.

The therapist may prepare the material before or have the client assist in the cutting of plaster strips. Have different sizes cut. The client decides what kind of mask they want: open or closed mouth and eyes. The client may decide to lie on their back or sit in a chair.

Check water temperature, and continue to tell them what you are doing, always checking their comfort level, especially with dripping water. Warm water is more comfortable.

When the mask is complete, the client will have to let it dry for a few minutes and then take it off by moving their facial muscles (it will start to lift as it dries)

Metaphor:

- Nurturing attention

- Trust/ vulnerability

- Concealing/ revealing

- Projection & regression

- Metamorphosis: new outward expression

Exploration:

- How did it feel having the mask made?

- What were your thoughts while the mask was being made?

- How did you choose to decorate your mask?

- What is the sense/ tone that the mask gives?

- Does your mask conceal or reveal?

Therapeutic Precautions:

- This is not an activity for everybody. Some people will not be comfortable with being touched or covered.

- Be careful not to drop water on unused Paris craft as it will render it unusable

- Make sure you ask whether they want to have their nose or eyes covered prior to starting the process.

Alternatives:

- Other body parts are popular to create forms of as well, like hands, thumbs, toes, and arms. Make sure that you can remove the plaster when it dries because it is like putting a body cast on someone - make the cast so that it can be taken off.

- Some clients feel more comfortable only doing the upper half of the face – like a masquerade mask.

- Cellophane or saran wrap can be used almost exclusively if the client is squeamish about cream. However, you must be very careful not to cover the nostrils for breathing. Some therapists use straws for the participant to breathe through the nostrils but many people find it very uncomfortable.

- Clay can be used to form a face and then the mask can be made over the clay form.

- There are also standard forms to make masks on that can be purchased.

- With young children, casts can be put on to dolls to work through anxiety caused by physical injury.

Superhero Mask Making (Hyrsko, 2006)

Directive: Brainstorm "Superhero Qualities" with a group or individual. Aspects like: goodness and valor, flight, strength, transformation, always win despite obstacles, maintain a degree of control, know right from wrong, no moral doubts, frustrations, or weaknesses, respected and popular in the community, outcasts (victims leaving home due to a traumatic past). Depending on group dynamics, there is the possibility of dramatization.

Intention:

- Act as a hero outside of sessions

- Address violence and power

- Identify personal weakness

- Have fun

- Identification

- Projection

Metaphor:

- There is the possibility to identify with hero qualities, to integrate the qualities of the ideal person.

Exploration:

Process questions:

- What was it like making the mask?

- What did you like about this activity?

- How does it feel wearing the mask?

Concrete:

- What is the significance of the colours you've chosen for your mask?

- Does this character have a name?

- Mask qualities, thickness, colours, and shape?

Metaphorical:

- What are the strengths/ talents of this superhero?

- What is its weakness?

- Is this someone specific?

Self-Reflective:

- What do you have in common with this character?

- What are your differences?

- Affect while in process

- Changes in physical presentation while wearing mask

- Interaction with group members while in character

Monsters & demons

Directive: To create, draw, or paint, a monster or demon out of whatever one chooses! It can be solid or a soft form, a puppet or a sculpture. Sometimes I will suggest to adults that they try to personify and express their "Demons of Self Doubt".

Recommended Populations: children, adolescents, adults

Intention:

- To externalize feelings

- To focus projection and the release of fear, anxiety and aggression

- To externalize critical super ego messages

- To have fun with creative expression

Materials and Method:

- Assorted construction materials: boxes of various sizes, egg cartons, toilet paper rolls

- Paints & brushes

- Masking tape

- Various cloth & materials

- Glue gun & white glue, wire, masking tape

- Paper mache and Paris craft

- Papers of all sizes

- Sponges, beads, plastics

- Lots of recycled good stuff

- Construct an interior base out of boxes etc. and tape

- Paint & decorate

Metaphor:

- To confront fears

- To create, therefore control that which scares you

- To externalize the 'monster/problem' encourages objective insight

- To express fears and anxieties

- To explore the character of the monster. Ask about his or her strengths and weaknesses/ vulnerabilities.

- To explore the shadow side

Therapeutic Precautions:

- Are they frightened or overwhelmed by their creation?

- Do they find it too revealing as they identify with it?

Dolls

Directive: To make a person out of fabric or paper.

- This can be done as paper cut out doll

- Pipe cleaner dolls with wooden bead heads, wrapped with foam and cloth and decorated. (Jhan Groom workshop at KATI, 2007)

- A sewing project for a rag doll:

- Soft body: sewing fabrics.

- Develop a paper pattern for the creation of the body

- Add Velcro to an opening in the tummy area where parts can be added inside the body and then closed.

- Use a doll (Barbie doll) as a base to explore social messages about being a woman in society.

- Scrunchy paper dolls made with rolled newspaper and masking tape.

- Large size dolls supported on a wooden frame.

- Hard body or head: wire & papier-mache.

- Create clothing, hair & accessories.

- Body can be made with clothes and stuffed with newspaper.

Recommended Population: children, adolescents, adults, elderly

Intention:

- To explore perception of self and others

- To reflect and reconstruct persona

- To explore feelings about body image

- To build positive self image & enhance self mastery

- To strengthen ego

Materials and Method:

- Assorted construction materials, and a variety of ways of attachment (Velcro, wire, needle & thread, glue guns, etc)

- Fabrics, yarns, stuffing

- Papier mache

- Old clothes

Metaphor:

- Construction of self (ideal, perceived, distorted, inside/outside)

Exploration:

- Similarities or differences to self

- Internal and external representations

- Inclusions and exclusions

- Behaviour towards created doll

- Accessories and material objects are often the focal point with dolls identifying what "belongs" to them.

Therapeutic Precautions: Working with body image may affect people deeply.

Styrofoam Print making

I was introduced to this method of printmaking by the noted Canadian printmaker, Evelyn Armstrong (1982). I have found it to be a very easy and successful method for individuals with a wide variety of abilities. We have even driven a wheel chair over the Styrofoam to make tire tread marks.

Directive: Draw / carve into a flat piece of Styrofoam. You can use many different tools to make marks on the Styrofoam because it is very soft. Roll out ink on glass and listen for the hiss that has the right consistency for inking. Roll ink onto carved side of Styrofoam. Place the paper onto Styrofoam and hold it. Carefully rub the back of the paper with the palm of your hand. Pull it gently off. One can make many prints on one page, one print on one page or perhaps posters or greeting cards. Even the simplest of lines or images looks very successful. It is good for creating a positive art making experience.

Recommended Population: Elderly, children, adolescents, adults
 Intention:

- To gain self mastery

- To gain self esteem

- To enhance pleasure

Materials and Method:

- Water soluble printing ink, rollers & glass

- Styrofoam trays or sheets

- Pencils

- Paper

Metaphor:

- Making a mark and then seeing it as a tangible record

- Dialogue about the image and the process as previously indicated

- Use a "what do you see?" process: a phenomenological approach.

- What was their enjoyment/ comfort level?

- The co-operation and sharing of supplies and work areas with others.

Therapeutic Precautions:

- Images come out reversed so you have to be careful with words and letters as they need to be done in 'mirror language'

Alternatives:

- Potato cuts and/ or rubber stamps

- Cardboard

Book Making

Directive: Making books can be a therapeutic activity. There are many great books on making books and the process is too detailed for the purpose of this manual.

Recommended Population: children, adolescents, adults

Intention:

- To provide an opportunity for individuation

- To provide an opportunity for creative expression

- To provide an opportunity for artistic mastery

- To create a useful object

- To create an object symbolic of containment

Materials and Method:

- There are many good sources for this information. Please see the bibliography.

- Paper bag books made from lunch bags were introduced by Jhan Groom, 2007.

Metaphor:

- A book can become a journal or a place for drawings and poems.

- It can provide both an opportunity for expression and containment.

- Stories, narratives or fairytales can be made into a book.

- Books can take on sculptural or 3 dimensional forms.

Therapeutic Precautions:

- Make sure you have appropriate materials and technical support so that the individual can successfully create a book.

Alternatives:

- Can be made to give away as a gift.

- Can be made for journaling through art therapy.

Flower Pots

Directive: Decorating flowerpots can be a nice transitional activity for the closing of a group or ending of individual sessions. Preferably a plant is ready to be divided and repotted or there are some small plants on hand for this activity.

Recommended Population: children, adolescents, adults
Intention:

- To create a transitional object

- To provide an opportunity for self-mastery

- To create a symbolic container that holds growth

- To provide an opportunity for spontaneous creative expression

Materials and Method:

- Acrylic paints

- Small plastic or earthenware flower pots

- Magazines for collage

- Podge or white glue

- Plants or seeds (optional)

Metaphor:

- Taking a living thing from art therapy can be symbolic of the individual's growth

- Metaphor of container

- Metaphor of growth

- Taking care of a plant implies taking care of self

Therapeutic Precautions:

- Be sure to provide very healthy plants that can survive this transition.

Mobiles

Directive: Create a mobile either choosing random objects, or with a particular theme in mind.

Recommended Population: children, adolescents, adults

Intention:

- To work with balance and the interdependent nature of reality

Materials and Method:

- Strings: Yarn, twine, cloth, clear fishing wire, telephone wire, chain, clothes line, string, braided fabrics

- Crossers: Coat hangers, found branches, popsicle sticks, wood, metal piping, broom sticks, dowels

- Objects: 2-D collage, clay, rocks, small sculptures, plastic figures, beads, found objects

- Have a variety of supplies from which to choose. If necessary help with connecting the crossers. Facilitate the process so that it can be done hanging if the client wishes.

Metaphor:

- The balance of many aspects and parts can make up a whole

- Aspects of self

- Dynamic and free movement with air flow

- Attachment and interrelationships

Exploration:

- How have you connected the objects to the structure?

- Is there a theme or common connection?

- Strings:

- Lengths in relation to whole

- Strength/ weakness

- Lengths in relation to other strings

- Crossers/ Hangers:

- Size- large, small, in relation to whole

- Space- crowded, spaced out

- Structure- strong, flimsy

- Relation to hanging objects

Therapeutic Precautions:

Sometimes very unstable/ vulnerable mobiles are created with precariously hung objects

Alternatives:

Artists can bring objects from home such as photographs, toys, collections etc. It could be created as a mobile family tree with photographs or as a gift for a new baby.

Papier mache

Directive: You can make many things out of paper- mache: bowls, masks, animals, puppet heads of all types, mobiles, sculptures, machines, vehicles, buildings, monsters, piñatas, trees, birds, people, furniture, trays, puppets, covering boxes. They can be spontaneous or directed. You will only be limited by your imagination.

Recommended Population: all populations for most of the projects

Intention:

- To discharge emotion

- To provide sensory stimulation

- To work on self- mastery

- To enhance self esteem

Materials and Method:

- Flour, water and newsprint

- White glue and water

- Or store bought paper mache paste

Metaphor:

- Recycling old pieces of paper into a new form

- Goopy material becomes an art object (metamorphosis)

- Messy during the process but the finished product is firm, useful and often beautiful

Therapeutic Precautions:

- Have aprons handy and be sure to work in an area that can allow for mess and spills.

Alternatives:

- Vary the inside of the structure depending on what you are creating. Try wires, boxes, balloons, paper, etc.

Chapter 14:

Student Studio & Supervision Activities

Directive with 3 triangles

Prior to doing this exercise it is important to discuss the focal points for looking at the art.

Directive: Make an image using three cut out triangles for each picture. Make one image that is pleasing to you, and one image that are displeasing to you.

Recommended Population: For students studying art or art therapy, student exercises and workshops.

Intention:

- To build therapeutic skills

- To explore one's personal interpretive framework

- To learn how easily self reflective dialogue can emerge out of an abstract image

- To practice phenomenological "What do you see?" looking and reflecting

- To be able to see movement, size, shape and dynamic relationships without as much intended personal symbolism

Materials and Method:

- White paper & coloured construction paper

- Glue & scissors

- Make 2 images. Use 2 pieces of paper.

- Take 3 triangles for each image/ piece of paper. The triangles and background can be any colour, or size.

Metaphor:

- This exercise is to help students listen to the metaphors expressed in a phenomenological description.

- Debrief by having the client/ artist describe the artwork. Pay close attention to the language used, in particular the metaphors. Encourage the client/artist to amplify (expand) the metaphor and to free associate. Listen for the movement into self-reflection and explore the associations.

- Can a student follow directions? i.e. work and create within the boundaries of only using 3 triangles

- Ability to be creative and use metaphor with stated boundaries

Therapeutic Precautions:

- Emphasize staying with questions progressing from concrete to metaphorical to self-reflective.

- Use the "What do you see?" procedure. (Betensky, 1995)

Art Activities for developing therapeutic skills

These directives can be useful for practicing debriefing skills in dyads or triads.

1) Create two abstract images perhaps using paint. Make one that you like that pleases you and one that you don't like - that displeases or disgusts you.

2) Use carousel paintings to practice making a phenomenological description.

3) Draw an image of your metaphor for healing or therapy. Write a few words or metaphors about it. Talk about metaphor theory, conventional metaphor and perceptual or innovative metaphor.

4) Make an image for the resources that helped you to survive a trauma. Then make art about the trauma.

5) Show a case study with just the images and then:

 a) Do a phenomenological description of the art;

 b) Then show the images and talk about them with the client's comments;

 c) Then do a feeling response in art.

Exercise for working with transference and counter transference

1) Description - take a moment to write down a description of a person (client, student, co-facilitator, parent) to whom you have a disproportionate emotional reaction. Describe how you see them.

2) Bracket out your assumptions – by writing down all assumptions.

3) Intentionality - what are your intentions?

4) Context – outline the situation – who else is in the picture?

5) Essence – tease out the feeling – the essence – write a poem.

Cultural Groups and Transitional Times

This idea came from Judith Siano in a personal conversation. (July, 2004)

Directive: Create small groups (3 to 5) around separate tables with a single colour of plasticine on a table. Each group is to start on a group project. Periodically the therapist will move a participant to another table. The participants are to take whatever material they have in their hands to the next table. Some people will stay at one table and others will have to adapt. This continues until all the groups have had a number of changes.

Metaphor:

- Moving and different cultures

- New groups and dynamics

Exploration:

- What was it like to be moved?

- What was it like to have someone new?

- How were you received in the new group?

- What was it like to stay?

Writing in a reflective phenomenological method.

This activity can be done in a number of ways. You can start with a word. In the beginning you must pay attention through all of your senses. The senses include visual perception, auditory perception, scent, taste, touch and internal proprioceptive sensations. It is important in paying attention to not reach for the first information but to allow one's sight and mind to be relaxed and achieve a diffuse gaze.

Writing as a reflective practice is not about thinking a specific thought and then writing down what your insight is. It is about writing as a process of discovery, as a way of perceiving as an active practice. The intention is to practice free writing in the way that one would free associate to an image, idea, sensation, or feeling. Let the words flow, and flow is a key word. Let all the words and thoughts come onto paper - remember that the creative process is about discovering what is and then allowing meaning to emerge through an interpretative practice.

In writing, just start with a description. Don't edit; write whatever comes to mind. If your mind wanders go with it and discover other places. When you are not sure what to write come back to the word and write it again repeating it until another image or thought comes to mind. Be aware of shifting from what may be in the foreground of your mind to background. How are things connected? How are they separate? What are you taking for granted? Write your assumptions that should be bracketed out. What are the clichés and metaphors that come to mind? What are the negative or shadow aspects that are lurking around? Let your mind roam free and write whatever occurs to you, including: memories, word play, associations, metaphors, parables and stories.

After writing, take some time to read what you have written. Underline in colour key phrases, insights, and aspects that seem of value. Think of this as looking for the horizon or gap where light can get through. What is the essence of what you have written? Reflect and distill the essence. Write a poem. Let a word or small poem – a haiku - emerge.

After the observations and paying attention, the writing, reflecting, and distilling the essence, it is important to be witnessed. The words or poems should be read aloud. The intention is to find a voice, an

authentic voice. This can be one's own voice or it can be another's voice created by placing yourself in another's shoes – another person, a plant, an animal or an object. The intention is to speak from a specific place and to empathize by giving an "I" voice.

Words: focus on household items, animals, plant parts, gardening, house cleaning, etc.

Getting To The Underbelly (Carpendale, 2002)

This art therapy supervision exercise combines art making and writing with the five central concepts of the phenomenological method. It is a deeply contemplative philosophical method in which one allows oneself to perceive the many levels of meaning implicit in the description of reality so that one can distill the essence. The phenomenological method is used to investigate the full subjective experiencing of things in the world as they present themselves in consciousness as immediate experiences.

The Exercise

This exercise can be used to explore any therapeutic issue or clinical concern, any aspect of transference or counter transference. It involves the creation of art in response to the specific concern. This can be done as post-session art or during supervision. The intention is to provide a framework to "unravel knots" and gain a better understanding.

The method is contemplative and meant to illuminate essence, not to establish scientific fact or causality. The steps in the process, as given, are not meant to be a recipe wherein the steps must follow each other in a specific order. Rather, the key concepts are intended to function as reflective foci from which one can move forward and backward using each to throw light on the others. For example, while reflecting upon Intentionality one may become aware of Assumptions that crowd the mind and distract one like the sounds of crows cracking walnuts on the tin roof outside one's bedroom window. While reflecting upon these assumptions, one may become of aware of the overall context of the situation and from this awareness grow an intuition of essence.

Materials and Method: drawing paper, oil pastels, pencils and/or felt pens.

In general, the process involves the making of five pieces of art. However, it could also be approached by creating one piece of art and then writing about it from the perspective of five key concepts. The purpose is to explore, as fully as possible, the supervision question through the lens of each step of the phenomenological method.

After making each piece of art, sit back and have a look. Get some distance and reflect. Write about it. Aim at an accurate description of what you see in the art. You may want to underline key phrases and note associations. You may want to write a poem (especially concerning your work on essence). Remember that essence will be discovered by intuition. Move back and forth between the images you did for each concept. Allow your intuition to connect personal meanings with objective factors. Intuition will integrate the whole process.

The exercise is broken down into five separate components below:

Description: The first piece of art created is an image of the situation. What is called for here is a clear depiction of the client, the therapist, and the art - not an explanation or interpretation. It is a return to the things themselves. This might be done in a number of different ways: a realistic narrative depiction, an abstract depiction of feelings, or symbolically as a metaphor or series of metaphors. Just as in creating art in therapy, there isn't a right or wrong way to do it.

Put the art up and have a look at it – perhaps step back and get some distance. The focus is on the actual artwork. The intent with this step is to look in order to see what is there. Observe the structure of each image, the figure ground relationships, the interrelated components, the dynamics, symbolism and style of expression.

Write a description of what you see. In this step we are looking for a pure description, not analytical reflection, scientific explanation, or any tracing back to inner psychological dynamics. If you really look and describe what you see you will already be 'bracketing out' your assumptions. With a premature focus on explanation we can lose the essence of the experience.

Reduction: This step is about looking at and setting aside one's assumptions. Such assumptions might include information about the client from the referral source (and the parent if the client is a child), the diagnosis, theoretical principles that seem applicable, different professionals' interpretations of the problem as well as the client's own

assumptions. These assumptions could also include the therapist's transferences and counter transferences. Here one 'brackets out' the question of the existence of the problem behaviour in order to devote attention to the question of underlying meaning.

Make a piece of art about your assumptions. Or write them down. You are trying to put down what you think you know or what other people have communicated to you. The purpose is to record all of these biases and assumptions so that you can set them aside and be able to look at the situation afresh. You might like to try free writing - writing continuously without picking up your pencil and without editing for a brief period.

If one doesn't go through a process of naming one's prejudices, biases, conceits, interpretations, beliefs and therapeutic goals, they tend to lurk around the therapeutic space causing disturbances. These assumptions may become more evident when we are unsure how to proceed therapeutically. In fact, it may not be the client who is stuck but ourselves because we are stuck on an interpretation or particular viewpoint.

Intentionality: All mental activity is directed towards an object – one can't think without thinking *about* something. All feeling or desire is directed towards something. This basic continuity between subject and object is an underlying characteristic of phenomenology. When one is intent on what one is looking at, the object of attention begins to exist more than before. It becomes important. It takes on meaning to explore. The intention here is to explore the existential meaning of life for the individual.

Make a piece of art focused on the concept of Intentionality. Explore the motivation and desire of the client and therapist. Explore the meaning of symbols, events, client's artwork etc. The intentions of the client will be in direct relation to their biases and assumptions. On the other hand, the therapist's intention might be important here. More biases and assumptions may come to the fore and then one may

wish to return to the second piece of art. Reflect on the art and write about it. Describe what you see and include any and all associations.

Essence: Reflect on the essence of the situation. Create another piece of art that expresses the essential feeling or what you see as the essential elements of the situation. Remember that the essence is discovered by intuiting - not by deducting. The conception of essence will be distilled from the description and aided by setting aside your assumptions. Poetry is often useful at this stage. If you are stuck at this step go on to the next step and come back to it when you look at all of the images together.

World: The human subject is in the world with others. Everyone's social interests and interactions in the external environment impinge upon one. We are aware of the existential dilemma that while we are always in relation to others, we are essentially alone, and we all die alone.

On a new sheet of paper draw or map out all the relevant relationships and place the situation in context. The client does not exist in isolation. This contextual element of the exercise pertains to the contemplation of the personal history, culture, your family of origin, significant life events, illness, losses and developmental stages of the client. This step also takes into account cross-cultural and ethical considerations. The client is in the world with fellow group members, family, peers, and so on. The exploration of this domain may also pertain to the therapist's own role in the world. While this step might involve creating a genogram or sociogram it can also be expressed in a more symbolic and creative manner.

Conclusion: There are a number of ways to work with this model, other than the one given above. One single piece of art might be created and then the five concepts explored through writing. Yet another way to approach this exercise would be to focus on the writing first, underline the key phrases, (sometimes called horizons) and then move to explore the essence in the art. The key phrases that one underlines are those that grab your attention - those statements that feel like they hold the potential of light or insight or alternately point to darkness and shadow.

One is aiming to underscore the indications of a gap, a space, a silence, a shout, a place or phrase that moves and refers to different levels.

One might also add a final step by creating a sixth piece of art as *reflective synthesis* (Kidd & Kidd, 1990) of the five original pieces. A further level of insight and integration might be achieved by putting all of this art up together and exploring it in dialogue with an art therapy supervisor, fellow supervisee or colleague.

Phenomenological Supervision Exercise

This exercise was introduced in a workshop at the American Art Therapy Association Conference (1996) in Philadelphia, by Jan Allen, Andrew Moorish and Warren Lett (absent presenter).

Directive: Draw a response to a clinical concern. Exchange the drawing with a colleague.

Look at the drawing. Write a description. Underline the key points. Discover the essence of the image. Do a drawing in response and pass it back to your fellow supervisor. Look at what has been drawn and written. Reflect and discuss.

Recommended Population: students or art therapists in supervision

Intention:

- To distill the essence

- To learn to look closely

- To learn to respond through art making

Materials and Method:

- Simple drawing or painting materials.

Therapeutic Precautions:

- Students might be upset by a fellow student's responses. There may need to be support for the dialogue in order to address the intention. This is not an exercise for clients. It is for students, supervisors, and other professionals.

References

Allen, Jan; Moorish, Andrew; Lett, Warren. (1996) *Experiential Supervision through the Intersubjective Dialogue: A workshop for therapists*. Philadelphia, AATA Conference.

Arnheim, Rudolf. (1996). *Toward a Psychology of Art*. Los Angeles: University of California Press.

Arnheim, Rudolf. (1974) *Art and Visual Perception: A Psychology of the Creative Eye*. Berkeley: University of California Press.

Axline, Virginia M. (1969). *Play Therapy*. Ballantine Books.

Barthes, Roland. *Mythologies*. Jonathan Cape Ltd. (Trans., 1972), Du Seuil. (Trans. From French, 1952)

Betensky, Mala Gitlin. (1995). *What do you see? Phenomenology of Therapeutic Art Expression*. London: Jessica Kingsley Publishers.

Bettis, J. Ed. (1969) An Introduction to Phenomenology: Merleau-Ponty, Maurice. *Phenomenology of Religion*. SCM Press Ltd. London. P.5-12.

Butler, Sandra. (1988) Current Dilemmas, Future Challenges: An Interdisciplinary Conference on Child Sexual Abuse. Vancouver, BC.

Burns, R. C. (1982) Self-Growth in Families. Kinetic Family Drawing (KFD) research and application. New York: Brunner-Mazel.

Cameron, Julia. (1996) *The Vein of Gold: A Journey to Your Creative Heart.* New York: G.P. Putnam's Sons.

Cane, Florence. (1951). *The Artist in Each of Us.* Vermont: Art Therapy Publications.

Carpendale, Monica. (2002) Getting to the Underbelly: Phenomenology and Art Therapy. CATA Journal, Winter, Vol 15 #2.

Carpendale, Monica (2003) *Kutenai Art Therapy Institute Studio Manual,* KATI Press, Nelson, BC.

Carpendale, Monica (2006) *Kutenai Art Therapy Institute Studio Manual.* 2nd edition. KATI Press, Nelson, BC.

Csikszentmihalyi, Mihaly. (1996) Creativity: Flow and the psychology of discovery and invention. New York: Harper Perennial.

Dalley, Tessa. (1989). *The Handbook of Art Therapy.* London: Tavistock Publications.

Devine, Carol. (2008) The Moon, the Stars and a Scar: Body mapping stories of women living with HIV/AIDS. *Border Crossings: a magazine of the arts.* Issue no. 105. Winnipeg, MA.

Douglas, Mary. (1966) *Purity and Danger: An Analysis of the Concepts of Pollution and Taboo.* London, New York: Ark Paperbacks.

Dreikurs, Sadie E. (1994). *Cows Can Be Purple.* Chicago: Adler School of Professional Psychology.

Erikson, Erik. (1987) *A Way of Looking at Things.* New York: W.W. Norton and Company.

Furth, Greg. (1988). *The Secret World of Drawings: Healing Through Art.* Boston: Sigo Press.

Gregory, Richard L. ed. (1987) *The Oxford Companion to the Mind.* Oxford University Press. Tarcher Inc.

Grudin, Robert. (1990). *The Grace of Great Things.* New York: Ticknor & Fields.

Haslam, Michael J. (1997) *Art Therapy Considered within the Tradition of Symbolic Healing.* The Canadian Art Therapy Association Journal. Volume 11, # 1, 2-16.

Hyrsko, Andrea. (2006) The Co-creative Aspects of Body Imagery through Art Therapy. Thesis, Kutenai Art Therapy Institute, Nelson, BC.

Kramer, Edith. (2000) *Art as Therapy.* London, England: Jessica Kingsley Pub.

Levick, Myra F. (1983). *They Could Not Talk and So They Drew: Children's Styles of Coping And Thinking.* Illinois: Charles C. Thomas Publisher Ltd.

Liebmann, Marian. (1986). *Art Therapy for Groups. A Handbook of Themes, Games, and Exercises.* Massachusetts: Brookline Books.

Liebmann, Marian (Ed.). (1996). *Arts Approaches to Conflict.* London: Jessica Kingsley Publishers.

Lowenfeld, Viktor. (1947) *Creative and Mental Growth.* New York: Macmillan Co.

Lummis, Christine, (2008) Body Mapping workshop at KATI, Nelson, BC.

Lusebrink, Vija Bergs. (1990) *Imagery and Visual Expression in Therapy.* New York: Plenum Press.

Lye, John. (1996) *Some Principles of Phenomenological Hermeneutics.* Website.

Kidd, S. & Kidd, J. (1990) *Experiential Method Qualitative Research in the Humanities Using Metaphysics and Phenomenology.* New York: Peter Lang Pub. Inc.

Kramer, Edith. (2002) *Art as Therapy.* London: Jessica Kingsley Pub.

Kramer, Edith. (1971). *Art as Therapy with Children.* New York: Schocken Books.

May, Rollo. (1975). *The Courage to Create.* New York: Bantam Books.

McCreight, Tim. (1996) *Design Language.* Cape Elizabeth, Maine: Brynmorgen Press, Inc.

McFague, Sally. (1997) *Super, Natural Christians: how we should love nature.* Minneapolis: Fortress Press.

Merleau-Ponty, (1969) Maurice. An Introduction to Phenomenology. What is Phenomenology? Bettis, Joseph, Dabney. Ed. *Phenomenology of Religion.* London: SCM Press Ltd.

Merleau-Ponty, M. (1962) Phenomenology of Perception, Routledge & Kegan, NJ. Cited in Betensky, M. (1995) *What do You See? Phenomenology of Therapeutic Art Expression.* London: Jessica Kingsley Publishers.

Messer, S. Sass, L. & Woolfolk, R. ed. (1988) *Hermeneutics and Psychological Theory: Interpretive perspectives on personality, psychotherapy, and psychopathology.* New Brunswick and London: Rutgers University Press.

Moon, Bruce L. (1990). *Existential Art Therapy: The Canvas Mirror.* Illinois: Charles C. Thomas Publisher.

Moon, Bruce L. (1992) *Essentials of Art Therapy Training and Practice.* Illinois: Charles C. Thomas Publisher.

Mueller- Nelson, Gertrud. (1991) *Here All Dwell Free: Stories to Heal The Wounded Feminine.* New York: Bantam Doubleday Dell Publishing Group, Inc.

Naumburg, Margaret. (1996). *Dynamically Oriented Art Therapy: Its Principles and Practice.* New York: Grune & Stratton.

Polanyi, Michael. (1967) *The Tacit Dimension.* London: Routledge & Kegan Paul Ltd.

Proulx, L., (2003) *Strengthening Emotional Ties through Parent-Child-Dyad Art Therapy. Interventions with Infants and Preschoolers.* London: Jessica Kingsley Pub.

Rhyne, Janie. (1984). *The Gestalt Art Experience.* Illinois: Magnolia Street Publishers.

Riley, Shirley. (1999). *Contemporary Art Therapy with Adolescents.* London: Jessica Kingsley Publishers.

Robbins, Arthur. (1998). *Therapeutic Presence.* London: Jessica Kingsley Publishers.

Robertson, Judith. (2005) *Integrating Art Therapy with Wilderness Therapy for Women Survivors of Abuse.* Thesis, Kutenai Art Therapy Institute, Nelson, BC.

Rubin, Judith Aron. (1987). *Approaches to Art Therapy: Theory and Technique.* Philadelphia: Brunner and Routledge.

Sandner, Donald M.D. (1991). *Navaho Symbols of Healing.* Vermont: Healing Arts Press.

Schaverien, Joy. (1992). *The Revealing Image.* New York, London: Tavistock & Routledge.

Seiden, Don. (2001) *Mind over matter: the uses of materials in art, education and therapy.* Chicago: Magnolia Street Pub.

Siano, Judith. (2004) *An Introduction to Art Therapy: the Haifa University approach for phenomenological observation.* My personal doctrine. (Spiral bound paper)

Simon, Rita. (1992). *The Symbolism of Style: Art as Therapy.* London: Tavistock and Routledge.

Swanston, Catherine. (2004) *Who's It? Scribble Tag with Children who have witnessed abuse.* Thesis, Kutenai Art Therapy Institute, Nelson, BC.

Tobin, Bruce. (1984) Expressive Therapies Course at the University of Victoria, BC.

Tobin, Bruce. (2001) Workshop at Kutenai Art Therapy Institute.

Van Manen, Max. (2002) www.phenomenologyonline.com retrieved 2003.

Van Manen, Max. (1990) *Researching Lived Experience.* London, Ontario: The Althouse Press. University of Western Ontario.

Wagner, Roy. (1986) *Symbols that stand for themselves.* Chicago: The University of Chicago Press.

Winnicott, D.W. (1971). *Playing and Reality.* New York: Routledge.

Bibliography

Allan, John. (1988). *Inscapes of the Child's World: Jungian Counseling in Schools and Clinics.* Dallas, Texas: Spring Publications Inc.

Anderson, Frances E. (1994). *Art Centered Education and Therapy for Children With Disabilities.* Illinois: Charles C. Thomas Publisher.

Arieti, Silvano. (1976). *Creativity: The Magic Synthesis.* New York: Basic Books Inc.

Bertoia, Judi. (1993). *Drawings from a Dying Child. Insights into Death from a Jungian Perspective.* London: Routledge.

Bush, Janet. (1997). *The Handbook of School Art Therapy.* Illinois: Charles C. Thomas Publisher Ltd.

Caprio-Orsini, Cindy. (1996) *A Thousand Words: Healing Through Art for People with Developmental Disabilities.* Quebec: Diverse City Press Inc.

Case, Caroline & Dalley, Tessa. (1990) *Working with Children in Art Therapy.* London: Tavistock/Routledge.

Coles, Robert. (1990) *The Spiritual Life of Children.* Boston: A Peter Davison Book, Houghton Mifflin Company.

Dalley, Tessa. (Ed.). (1984) *Art as Therapy: An Introduction to the Use of Art as a Therapeutic Technique.* London: Tavistock Publications.

Dalley, Tessa. (1989). *The Handbook of Art Therapy.* London: Tavistock Publications.

Dalley, Tessa. (Ed.). (1987). *Images of Art Therapy. New Developments in Theory and Practice.* London: Tavistock Publications.

Evans, Kathy and Dubowski, Janek. (2001) *Art Therapy with Children on the Autistic Spectrum.* London: Jessica Kingsley Publishers.

Farrington, Liz. (1993). *Painting The Fire.* Sausalito: Enchante Publishing.

Fausek, Diane. (1997). *A Practical Guide To Art Therapy Groups.* New York: The Hawthorn Press.

Ferrara, Nadia. (1999). *Emotional Expression Among Cree Indians.* London: Jessica Kingsley Publishers.

Gardner, Howard. (1982). Art, Mind & Brain: A Cognitive Approach to Creativity. New York: Basic Books Inc.

Gerity, Lani Alaine. (1999). *Creativity and The Disassociative Patient.* London: Jessica Kingsley Publishers.

Herberholz, Barbara. (1974). *Early Childhood Art.* Iowa: Wm. C. Brown Co. Publishers.

Henley, David. (2002). *Clay works in Art Therapy: Plying the Sacred Circle.* London: Jessica Kingsley Publishers.

Henley, David R. (1992). *Exceptional Children, Exceptional Art.* Massachusetts: Davis Publications, Inc

Kent, Corita & Steward, Jan. (1992). *Learning by the Heart: Teachings to Free the Creative Spirit.* Toronto: Bantam Books.

Landgarten, Helen. (1980). *Clinical Art Therapy.* New York: Brunner/Mazel.

Malchiodi, Cathy A. (Ed.) *Medical Art Therapy With Children*. London: Jessica Kingsley Publishers. 1999.

Malchiodi, Cathy A. (1998). *Understanding Children's Drawings*. New York: The Guilford Press.

McNiff, Shaun. (1992). *Art as Medicine: Creating a Therapy of the Imagination*. Boston: Shambala.

Naumburg, Margaret. (1973). *An Introduction to Art Therapy: Studies of the Free Art Expression of Behaviour Problem Children and Adolescents as a Means of Diagnosis and Therapy*. New York: Teachers College Press.

Nucho, Aino. (1987) *The Psychocybernetic Model of Art Therapy*. Springfield, Illinois: Charles Thomas Pub.

Oaklander, Violet. (1978). *Windows to Our Children*. Utah: Real People Press.

Rogers, Natalie. (1993). *The Creative Connection: Expressive Arts as Healing*. California: Science & Behaviour Books Inc.

Rubin, J.A., (1977). *Child Art Therapy: Understanding and Helping Children Grow Through Art*. New York: Van Nostrand Reinhold.

Rubin, Judith. (1984). *The Art of Art Therapy*. New York: Brunner/Mazel.

Safran, Diane Stein. (2002). *Art Therapy and AD/HD: Diagnostic and Therapeutic Approaches*. London: Jessica Kingsley Publishers.

Waller, Diane. (1993) *Group Interactive Art Therapy*. New York: Routledge.

Appendix 1:

Blue Heron Communication Games

The Blue Heron Therapeutic Board games developed by Monica Carpendale and Blake Parker can be used in both individual and group sessions. Virginia Axline (1969), a pioneer in play therapy, established eight basis principles for play therapy. These principles are important in how the games are played. They also provide an opportunity to manifest these therapeutic objectives.

1. "The therapist must develop a warm, friendly relationship with the child, in which good rapport is established as soon as possible." (Axline, 1969: p. 73) Board games are familiar to a child and can help reduce their anxiety because children often feel that there is something wrong with them if they are sent to counseling. They think perhaps it is because they are bad or bad things have happened to them. They are worried and wonder what the therapist will be like and what will they be expected to do, will they do it right, or will they get in trouble here too. So offering a game as a choice of activity is like offering a known element in an unknown environment. There is an opportunity for interaction, warmth, laughter, and friendliness. Starting with one of the feeling games like the Goose Game of Feelings or Let's Go Fish a Memory also provides an opportunity to reflect back or normalize feelings of anxiety, nervousness or shyness in meeting someone new. Both these games provide many opportunities for establishing commonality in feelings and experiences, demonstrating Axline's second principle:

2. "The therapist accepts the child exactly as he [she] is." (Axline, 1969: p. 73) All feelings and experiences are to be accepted as expressed. There are no "wrong" answers. It is more important to encourage a

child to speak and offer their experiences and feelings than to worry or correct their use of language - a child may interpret or use a feeling word in a way that makes one wonder if they understand the word correctly. Accept their response and when you have an opportunity offer an example for yourself that illustrates the feeling. In fact, correcting their use of the word may easily lead to the child not wanting to play anymore. Sometimes what may seem like an inappropriate application of a feeling word may actually provide some insight into the feelings experienced in the situation being spoken about. It is also important that there be no "put-downs", shock, or critical response. If for example, when a child lands on the "mean" square they actually tell about a really mean thing that they did. They should be acknowledged for their courage in sharing this kind of behaviour. Be very sensitive and aware of your own responses as you can also use the game to expand Axline's third principle:

3. "The therapist establishes a feeling of permissiveness in the relationship so that the child feels free to express his feelings completely." (Axline, 1969: p. 73) The therapist has an opportunity each turn to use herself to describe, express and relate her own feelings and responses to situations. With the give and take of turns and in the Goose Game of having to exchange places with the other player when you land on a standing goose, there is a perfect opportunity to reflect and recognize the feelings a child has expressed by offering from one's own experience a place in common. This as you can easily see is a concrete way to naturally introduce in the play Axline's fourth principle:

4. "The therapist is alert to recognize the feelings the child is expressing and reflects those feelings back to him/her in such a manner that he/she gains insight into his/her behaviour." (Axline, 1969: p. 73) A sensitive therapist can reflect and expand the feeling expressed to offer insight in a personal and non-threatening way by his or her own effective use of self. The structure of the game and exchange of turns, and movement through a whole spectrum of feelings prevents an intense focus on a problem, feeling or situation, but allows for the problems a child feels and experiences to be expressed within a rainbow of other feelings and positive experiences.

5. "The therapist maintains a deep respect for the child's ability to solve his own problems if given an opportunity to do so. The responsibility to make choices and to institute change is the child's." (Axline, 1969: p. 73) This principle is integral to both the Hopscotch Game of Playground situations and the Play it Safe game. In the hopscotch game situations are presented on the cards for which the player must identify the feeling and offer possible solutions. All solutions are to be accepted without criticism. In fact, the therapist has an opportunity to model acceptance of feeling like perhaps being violent or aggressive in response and self reflect on more positive solutions, or even express the difficulties of a situation and not knowing how to respond and asking the child for suggestions. The goal here is to learn to brainstorm different responses to problems and to respect and believe in the child's ability to develop more and more healthy and appropriate responses in their life by becoming more creative and able to see the possibility of alternative responses.

6. "The therapist does not attempt to direct the child's actions or conversation in any manner. The child leads the way; the therapist follows." (Axline, 1969: p. 73) There is a structure to the interaction but there is a great deal of freedom within the limits of the game. These games provide an opportunity for a child to introduce different topics or issues as they need and it is important that the therapist is aware of the implications underlying their communications.

7. "The therapist does not attempt to hurry the therapy along. It is a gradual process and is recognized as such by the therapist." (Axline, 1969: p. 73-74) Game playing is an enjoyable activity and provides a concrete opportunity to explore issues and practice communication skills. It can be a relaxing way to approach counseling.

8. "The therapist establishes only those limitations that are necessary to anchor the therapy to the world of reality and to make the child aware of his responsibility in the relationship." (Axline, 1969: p. 74) The natural limits of game structure and how rules are applied or

adapted by children offers a safe place to explore issues of power and control and help a child to decide on the limitations they will play by.

About the Author

Monica Carpendale, BFA, DVATI, RCAT, BCATR, a registered Canadian Art Therapist is the founder and executive director of the Kutenai Art Therapy Institute in Nelson, BC. She has 24 years of experience in art therapy, teaching and supervising. At the Kutenai Art Therapy Institute Monica has developed a phenomenological approach to art therapy that includes metaphor theory, social constructivism, and hermeneutics. She is currently exploring ecological identity work in an evolving form of earth art therapy. For Monica, making "art" and making "special" has always been a part of her life. Drawing, painting, gluing and taping together have been ways of creating the world.

Monica has been involved in education and art for many years. As a teenager she was part of the Knowplace, the first student started free high school in Vancouver, in the late sixties. She continued to be involved in alternative education both in teaching and for her own children. Monica attended the Kootenay School of the Arts, David Thompson University and was awarded a BFA from the University of Victoria. She trained to be an art therapist at the Vancouver Art Therapy Institute with Lois Woolf, Dr. Fischer and Talia Garber. Monica has specialized in working with trauma, abuse, loss, grief, and cross-cultural issues. She has provided many workshops for First Nations organizations and communities.

Monica developed 9 therapeutic communication board games out of her private practice and she has been the inventor and co-designer, with Blake Parker, of the Blue Heron Therapeutic Games. She has published several articles in the Canadian Art Therapy Journal and presented nationally and internationally on a phenomenological approach to art and poetry therapy.

She has produced a video on the Art of Lorraine Beninger, which demonstrates clearly the value of art therapy with a woman who has multiple disabilities, including being legally blind. She is currently

completing a DVD entitled An Angel with a Broken Wing, which shows the value of art therapy with a woman living with chronic post-traumatic stress disorder.

Monica has lived for many years in the West Kootenays with Blake Parker, the late performance poet. She has a son, a daughter, a bonus daughter, and seven grandchildren.

Printed in the USA
CPSIA information can be obtained
at www.ICGtesting.com
LVHW020604170924
791293LV00001B/122